中國畫

CHIANG YEE

THE CHINESE EYE

An Interpretation of
Chinese Painting

With a Preface by
S. I. HSIUNG

INDIANA UNIVERSITY PRESS
Bloomington & London

TO
MY BROTHER

PREFACE

WHEN I went to see a production of my play in Dublin, I met a Professor who asked me whether I wrote poetry and whether it was true that nearly everybody in China could write poetry. I replied in the affirmative and he exclaimed what a great amount of rubbish we must have! How true! But here, very few people can write poetry, and the result is you have an even greater amount of rubbish than we have! Had I known that he was a playwright and that I had shaken at least twenty dramatists by the hand that evening, and that about half the audience of that performance were authors of the Abbey or the Gate, I would have made some remarks about the drama.

In China, most of us can not only write poetry, but also paint pictures. An artist generally means both a poet and a painter. Mr. Chiang, the author of this informative and entertaining book, has, therefore, more than one string to his bow. He is nominally a scientist and received, many years ago, his first degree in chemistry at the University of Nanking. But his activities show us he is more a statesman than a scientist, for the governing of various districts in the Yangtze valley has occupied

most of his time for the past few years. And
those who take him to be a statesman will think
they are mistaken when they learn that he is now
lecturing on Chinese at the School of Oriental
Studies. To those who have seen his pictures
at the 'Men of the Trees' Exhibition last
winter, and the Modern Chinese Painting
Exhibition at the New Burlington Galleries
this spring, and at other exhibitions on the
Continent, he is definitely an artist. His
more intimate friends who have read his
recently published poems on English scenery
will no doubt have another name for him.

My friend Mr. Chiang, however, has one
drawback: he cannot talk! He sometimes
signs his pictures with the pen-name of 'The
Silent Priest'. I know he cannot preach, but
he can be silent, and silent water runs deep.
Whenever he shuts himself up for a certain
period during which you hear nothing from
him, he is sure to produce a series of exquisite
paintings or a volume of lovely poems. Re-
cently he has been unusually quiet, and natur-
ally I was not in the least surprised when one
day he handed me this interesting book, but
surprisingly honoured when he asked me
for a Preface.

As a playwright, one thing I must protest
against: dramatic criticism written by men who
cannot even write two lines of blank verse! And

on the other hand, I would willingly pawn
my gown to buy books of criticisms written
by experienced dramatists. Lest you do not
realise what this means, I must tell you that
a Chinese scholar considers his gown so
indispensable that he would rather part with
his pants and trousers first. Now, need I tell
you that *The Chinese Eye* is a book not only
for the general public, but also for connois-
seurs and artists themselves? It deals with
many interesting angles of Chinese painting
which very few of its predecessors have ever
touched. Books on Chinese Art already exist-
ing were all written by Western critics whose
conceptions, though valuable, would certainly
give an interpretation somewhat different from
that of Chinese artists. The author of this book
treats the history and principles and philosophy
of painting so deftly and yet so simply that one
cannot help being instructed and entertained at
the same time. It is not a big book, and, thank
Heavens, not an academic book! If Mr. Chiang
has achieved nothing else but has succeeded
in writing about Chinese Art without being
tiresomely academic, both the author and the
reader ought to be highly congratulated.

<div align="right">S. I. HSIUNG</div>

HAMPSTEAD, LONDON
SEPTEMBER, 1935

ACKNOWLEDGEMENTS

I CORDIALLY thank Mr. Alan White, without whose encouragement this book would never have been written. To Miss Innes Jackson, whose help has placed me so much in her debt, it is impossible adequately to express my gratitude. She has rendered into lucid English my clumsy expressions, translated many quotations from Chinese poetry in the chapter on 'Painting and Literature', and drawn my attention to parallels in European thought. My grateful thanks are also due to Mr. Hsiung, who besides generously contributing the Preface, has given me valuable help in reading through the whole MS., and has permitted me to use his translation for most of the quotations, especially in the chapter on 'Painting and Philosophy'.

C. Y.

LONDON
SEPTEMBER 1935

AUTHOR'S PREFACE
TO THE SECOND EDITION

I WAS very much surprised to learn that this book was actually to be reprinted one month after publication. Book sales, like weathercocks, show which way the wind is blowing, and I am gladly forced to recognise that, despite shortcomings in the book itself, the public is certainly interested in Chinese Art; and, after all, *The Chinese Eye* may have filled in a few cracks in the fabric of its knowledge.

The transliteration of Chinese is a perpetual problem: one attempts to make one's system coincide as nearly as possible with the native sounds. But in this edition I have brought the Chinese names uniformly under the Wade notation, even though I do not in all cases agree with it. I do this for convenience, having discovered that Wade's is the system most familiar to European readers.

I should mention that the illustrations in *The Chinese Eye* are mainly reproductions from paintings in private collections in China, and many of them are greatly reduced in size. It would be fortunate if students could study the originals, but I am doubtful of the possibilities.

I wish to record my gratitude to those reviewers who have drawn my attention to certain errors in the text.

LONDON C. Y.
JANUARY, 1936

CONTENTS

ILLUSTRATIONS

FIGURES

BIRDS, FLOWERS AND ANIMALS

INTRODUCTION

FORTY or fifty years ago reproductions of Western paintings began to filter into China. At the outset, for one reason or another, we Chinese found them very difficult to appreciate, or even to understand. Most of us were not very familiar with the religion and culture of the West, and so the significance of the subject-matter escaped us. About the same time, photographs of Western life and scenes were introduced into our country. Until then our ideas on these things had been hazy and unsubstantial. Now, from a selection of photographs and works of art, we hoped to draw up a picture of life as it went on outside the borders of Asia. Naturally there were misconceptions. Since those days, communications have gradually opened up, and we ourselves have travelled into Europe and America to learn the theories, thought, literature, art, ideals of those great continents, and we have carried back our gleanings to China. Eventually, besides familiarising themselves with the artistic theories of the West, our painters learnt themselves to paint in the Western way, adopting Western media and

methods. Nowadays it is not uncommon to see Exhibitions in our chief cities of what are termed 'New School' and 'Western' paintings, executed by our own artists.

Before I came to England, I was interested myself in this adoption of Western ideas, but I was unwilling to base my judgments upon reproductions. I desired to see the originals, to bring my own mind within reach of the creator's thought, to be able to analyse his processes and regulations. Only then could I seize the true value of the works. If one were to spend a week studying a reproduction of Constable's 'Cornfield', how could one hope even then to understand it if one had never seen an English farm or an English elm tree? The smallest object, the most insignificant human action, is characteristic of the country which fostered it. I made up my mind at that time to go abroad and observe them for myself.

It is true that Chinese painting has been known in the West for a century or more, and that nearly every large museum or private collection contains some examples of Chinese art and critical works have been written on Chinese painting. But to my mind, Western people have seldom tried to understand the true background of these pictures, and very rarely attempted to master their technique.

Discriminating appreciators are correspondingly few. Perhaps your love of our forms and scenes in paint can never be as great as our own: our customs, our taste, our psychology, our whole life are very different, and it is just these elements which are the most formidable barriers to understanding. In this Introduction I cannot hope to show the whole Chinese mind in its relation to art, but I can erect a few signposts. I believe that with regard to beauty and artistic value there is no difference between the arts of any two nations or cultural regions in the world. But there are obvious differences in technique and media. Art speaks to the human heart and appeals to the human soul; and Chinese masterpieces have come to be admired in the West just as much as Western masterpieces have appealed to Chinese minds. One point of difference still remains: the inward belief which the artist consciously or unconsciously expresses in his work and conveys to the beholder. No art can reach an established manner in a flash. It must *grow*; and growth means change, and change is always slow. Our customs, our tastes, our conventional ideas, and traditional philosophy, themselves the products of centuries of development, have deeply influenced our art. Without some knowledge of these it is difficult for members of a different civilisation to grasp the aims of

Chinese painters. And this allows nothing for the great differences in the instruments of painting. Oil pigment and canvas are hardly ever used in China, and even our brushes are differently shaped.

Chinese artists are not merely painters of pictures; they are expected to be fine and disciplined personalities, thoughtful as well as imaginative and sensitive. Painting has never been practised as a profession: in the past it was regarded as shameful to sell works of art for money. No good picture can have a cash value, for it represents the soul of the artist and souls are not for sale. Even the thought of fine paintings falling into the hands of people with money but no soul was distasteful; and folk who wanted to buy pictures because it was the fashionable thing to do, were avoided by the artists who preferred to die of starvation or be put to death for disobedience rather than let their work fall into the hands of unintelligent or unsympathetic persons, however powerful. On the other hand they would unhesitatingly give their works to friends who would appreciate and treasure them. Nowadays, however, following fifty years of immense economic changes in China, many artists are unable to maintain this attitude and their works have to be for sale.

I have been in England for a good many

years, and cannot claim to have learnt all the ways of Western life, but from my limited observation I feel that there are not a few attitudes towards things upon which we differ. If I bring forward a few concrete examples, drawn from the simple events of our life, you may possibly be able to appreciate our point of view towards our own paintings better than through some theoretical dissertation.

I have only just learned the correct time for taking tea in England; and I understand that one should add milk and sugar and eat some cakes with it as well. But our habit is not so: we have no regular time for tea; we drink it when we like, and not merely for refreshment: it is a form of sociability, a unifying element whenever friends may meet. Nor do we need any milk or sugar to flavour it; we think the natural flavour and scent of the leaves should reach our palate in their original purity, and so we sip it appreciatively, little by little instead of cup by cup.

This habit of ours is not without its application in the world of art. We feel that a painting may not require an elaborate technique; it should speak simply from the power of its basic inspiration. That partly explains the Chinese preference for plain ink; we use few colours to help out the effect, just as we do not add milk or sugar to improve the tea's flavour. If we

are drawing a single flower or bird, we often leave a blank background; as I said, we take no cakes with our tea! Nowadays, there are some of us indeed who have learned to take all these etceteras. I might add that I believe those Western people who drink black coffee can certainly appreciate our paintings—even more if they drink black coffee without sugar!

Like most people, we are fond of drinking wine; no artist or literary man can be without it, and we are more ready to appraise than censure a poet for toping. But we have no specified occasions for this indulgence; if we want to drink we take no note of anything, more especially time. Our glasses, too, are smaller than egg-cups, and like the tea, we sip it slowly, gradually, taste by taste; not heartily as you gulp down beer. This is how we eye our paintings: convinced that a hasty glance can only bring a superficial satisfaction, we look at them at leisure with thought and open heart, until slowly the inner significance sinks into our minds and the imagination is fed to the full.

Once when I was boating on the Thames, oblivious of everything but the gentle sound of the water as it splashed against the banks, I began to hear in the distance some Scottish bagpipes. Suddenly I realised where I was!

In our Chinese taste we love to listen to a very
soft, clear note from a lute, blown on the wind.
We often play on the guitar or seven-stringed
lute, sitting in the seclusion of a bamboo or
pine-grove. That kind of quietism is really
our paradise, and you will find its atmosphere
over and over again in our paintings, in con-
trast with the scenes of dramatic movement
which are the special achievements of European
art.

Our poets and painters, you will find, are
much preoccupied with the moon in their
creations. In their own lives they are also
moon-lovers: often they will bring wine-pot
and lute and sit solitary beside a pine to enjoy
the moon on a quiet night. I have seldom met
this taste in the West; perhaps because of the
weather or because the moon in this part of
the world shines for so short a time at night!

Snow also is beloved of our people, and you
may often find a snowy landscape-painting, or
a snow scene in poetry. I have not seen very
much snow during my years of London life,
but I have gathered from newspapers and films
that Westerners too feel a friendship for it,
though they have a different way of showing
this. They go out in ski-ing parties; the
children have snowball-fights; everyone laughs
and shouts with pleasure at the sport it makes!
But we have a story about a poet called Mêng

Hao-Jan, who went out in the snow riding on a donkey and looking for plum-flowers. We also have a well-known phrase: 'To walk slowly over the snow looking for poetic inspiration.' I have a friend who lived beside a Swiss lake for three years. He wrote to me last winter about a day of heavy snowfall. It was beautiful, he said, to look over the endless white expanse—what we call 'the Silver World.' Most people preferred to huddle over their fires indoors, but he could not repress his Chinese instinct. He went out towards the lake, walking very slowly here and there as his fancy pleased, gazing on all sides as far as the eye could reach, taking inexpressible joy in the scene. He told me that he felt human society was the ugliest thing in the world at that time. Human affairs seemed honest enough on the surface, yet in fact they concealed dark blots of cheating, pretence, and conflict. The only pure thing apparently was this huge snowdrift covering all the world; it might symbolise the original condition of man's thought. For this reason we should enjoy it; nowhere else could we find anything so pure and white. So he moralised in his letter to me.

From this story you can see how our enjoyment of snow is due to a state somewhat different from yours. If you can understand the

feeling of our great masters' snow pictures, then you will know how our people delight in it.

We love Nature; we consider human beings as but one small part of all created things. We feel that the original good and simple character of man has been gradually lost in the progress of civilisation, and so we shift our affection toward other parts of the universe. Especially we love animals, birds, fish, and flowers, and you find these more frequently than the human form as subjects of Chinese paintings. We love birds particularly; sometimes in China you will see a man carrying a cage, or with a bird perched on his shoulder, taking his pet for an airing, just as you take your dogs for a run. We take them for a slow stroll in the forest, we put them in a cage and hang it in the trees to let them sing with their companions of the forest, and answer them. We sit down and listen to their singing. We cannot pretend to run as fast as dogs, and so we find birds more companionable.

As I have tried to show, we love natural truth; our philosophers were convinced that human desire has grown beyond bounds; man's eagerness to grasp the object of his desire gives rise to much unnatural and untruthful behaviour. Man, we think, is no higher in the scale of things than any other kind of matter that comes into being; rather, he has tended to

falsify his original nature, and for that reason we prefer those things that live by instinct or natural compulsion; they are at least true to the purpose for which they were created. We paint figures occasionally, but not so much as you do in the West.

As for nude paintings, they are unknown in China. It is a matter of traditional thought: you in the West have sublimated the beauty of the human form, and have made it the basis of composition and draughtsmanship. But we hold the view that the human capacity for calculated action and behaviour has led to all kinds of evil conduct. The human body grows corrupt from the crooked thoughts it harbours, and so we do not care to paint it.

There was one stage in the history of our art when figure-painting was fairly popular for a time. The main object of these works of art seems to have been a display of luxurious and gorgeous-looking costumes and drapery. They had the effect of enticing people into extravagant modes of life, and of making the poor more aware of their privations. This fashion, however, was out of keeping with our traditional thought: our great thinkers have always tried to train the people to rely on spiritual comforts. We can enjoy natural scenery everywhere and at all times ; we need not spend so much as a farthing on

getting a quiet, satisfied mood. Nor need we trouble to adorn our bodies with unnatural beautifiers to please the painter's eye; he can bring loveliness out of his imagination if he chooses! Our idea of artistic beauty, however, lies more often in that which is natural and which has personality, than in the perfection of proportion, build, and colouring, which was the Greek ideal. We have a saying that sounds somewhat paradoxical—that a lady looks most beautiful when she is plainest—that is, when she is her simple, unaided, natural self. There was also a painter called 'Old Lotus' Ch'ên, a figure-painter, who lengthened the heads and shortened the bodies of his figures to an exaggerated degree. Many onlookers made such remarks as, 'Not like a person' or 'Hopelessly disproportionate!' but among our art critics his reputation is very high indeed; a fact which gives some indication of our taste in this branch of art.

I remember once going to a flower show in England with a lady. The ticket was given me by someone who specially recommended the display of orchids. When I arrived, the place was so crowded that we could hardly obtain entrance. My first impression of the exhibits was of their brilliant colouring; puce, sharp green and bright yellow. Everywhere people were making exclamations of delight

and astonishment; 'Lovely!' 'Gorgeous!' 'Mar-
vellous!' and so on. My head began to ache.
Eventually we found the orchid tent, and
what was my surprise to find that even
these orchids had the same kind of colourings
as the flowers we had just seen, only slightly
less vivid!

Chinese orchids have far less variety of colour
and form. They would not have been noticed
had they been among those exhibits. Perhaps
that is just why they were absent. However,
we love our orchids for their delicate pale
yellow-green colour and faint elusive perfume.
Their leaves are long and slender, very well
suited to Chinese brush-work, near as it is to
calligraphy. Many an artist of ours in the past
specialised in this subject, painting nothing but
orchids all his life. It is a favourite subject for
our poets too.

All the trees which I have seen in many
London parks are well planted and regular in
shape, carefully trimmed and tended. But the
typical scenery in China is mountainous and
rocky. Our trees, even in our own gardens, are
left to twist themselves into any fanciful shape
that pleases Nature; irregularity of planting
and growth are accounted a beauty rather than
otherwise. We often construct rocky piles
to represent miniature mountains inside our
gardens. China has her typical geographical

phenomena which have influenced her conven-
tional thought and traditional philosophies. In
turn her arts, particularly painting, reveal these
philosophies with the necessary literary impli-
cations. It is possible of course to enjoy our
paintings without any reference to their literary
implications, but it will be more satisfying if
they are understood.

Our love of Nature is based upon a desire
to identify our minds with her and to enjoy
her as she is. But the West tries to imitate,
to control, and to master her. For example,
you have learned to make artificial flowers
whose unreality can hardly be detected—this is
what I call your imitation of Nature; you have
invented methods for keeping harsh wind and
rain from harming trees and flowers—what I
call your control of Nature; you can force
flowers to bloom out of season—your mastery
of Nature. Your careful nurturing of hothouse
blooms must contrast with our appreciation of
withering leaves—dying plants. Our poets
and painters take a melancholy delight in
faded glories and dying memories of the past,
and so they often paint or describe the lotus
after the time of its splendour, for the sake of
its associations with these things.

We can contemplate calmly the natural
process of all things towards eclipse; we enjoy
the twilight as much as the sparkling light of

midday, but you prefer to look upon the most splendid blossoms that man's skill can rear, when they are at the zenith of their beauty, believing, no doubt, that even on earth one may have glimpses of perfection.

All these examples I have drawn are intended to indicate the differing environments of Chinese and Western art. None of my observations has been passed in any spirit of carping superiority, but since my book is upon 'Chinese Painting' and not 'World Painting', I have been obliged to take my stand upon Chinese ground, and to pass over such elements of Western life and thought as have no parallel in the East. It is my object, not that you should weigh one art or one life against another, for in such things there can be no scale of assessment, but that you should have some data for understanding and appreciating Chinese painting both in its triumphs and its shortcomings. Of course there are technical considerations, over and above the differences in mental outlook which I have tried to indicate in this chapter. In the course of the book I hope to make all these clear, and to give you a critical standard of appreciation by which you may applaud or condemn.

HISTORICAL SKETCH

I INTEND to give only a brief outline of the history of Chinese painting, to provide the reader with a background of fact, against which I may throw, as on a screen, the ideas of the following chapters. I shall mention few names, being of the opinion that a name without a 'life' attached is not only bewildering but pointless. Whenever an artist has inaugurated some new movement or style which has had an important bearing upon the subsequent development of our painting I have introduced him by name, and occasionally spoken of one or two distinguished followers, in order that the reader may be aware of their period and significance when he comes across them in other parts of the book. It is my purpose to indicate the flow of ideas and inner meanings, rather than to preserve an historical sequence.

PRIMITIVE TIMES

Any enquiry into the nature of an art must have some dealings with its origins. The exact condition of the primitive stage, however, will be largely hypothetical—all the more so in

a country like China, which has so ancient a civilisation, and where records of the earliest times are consequently rare.

We shall have to make a beginning from our written characters, for we suppose these to be our earliest form of picture, and even their present form has not entirely lost the pictorial quality. Primitive man could use his brain a little, differing thus from animals. The ancient Chinese invented a method of knotting strings as a means of remembering actions past or to come. A little later, but still in the mists of a very distant past, a certain Emperor known as Fu Hsi (about the 28th cent. B.C.) drew up a system of linear combinations to represent all the observed phenomena of heaven and earth. It was originally derived from two signs corresponding to the positive and negative principles of the universe, 'Yang' and 'Yin' as they are called in Chinese.

Yang Yin

From these two signs he developed eight different groups of lines, representing Heaven, Earth, Wind, Thunder, Water, Fire, Mountains, and Rivers. It is interesting to note that though rain, hail, and snow are all included in water, river is separated from it, and mountain separated from earth. Mountains and rivers hold a high place in our hearts.

Under the eight headings shown below Fu Hsi proceeded to classify the other objects of creation.

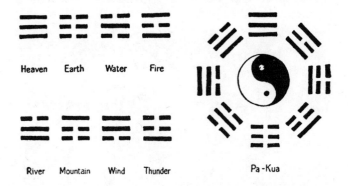

| Heaven | Earth | Water | Fire |

| River | Mountain | Wind | Thunder |

Pa-Kua

For instance, the first sign represented heaven, emperor, father, gold, head, horse, and so on, and the second sign represented earth, mother, cloth, breast, cow, and so on. The items under each head will be seen to have some quality in common: those in the first list share an element of strength and hardness; those in the second, weakness and softness. Thus these eight line combinations (in Chinese, Pa-Kua) were the origin of the characters and the seed from which painting sprang.

At the time of the Yellow Emperor (2697-2596 B.C.) there was an Imperial Recorder by name T'sang Chieh. This Recorder devised a kind of tally system to simplify agreements

between certain parties. On his sticks he en-
graved a very primitive image of some natural
object. This was a development of the knotted
strings, and a decided movement towards a

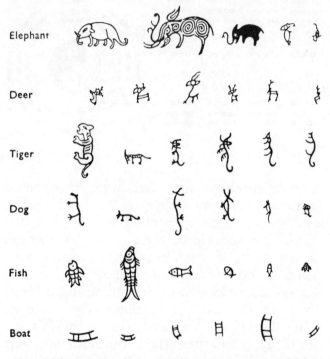

distinct art. Picture-writing evolved in China
from this point: on a few archaeological remains
there are imprinted the records of early char-
acters; for example, the Tripod engravings of
the Hsia dynasty (2205-1786 B.C.), the bone

and shell characters of the Shang dynasty (1786–1135 B.C.) and the engraved bronzes of the Chou dynasty (1135-247 B.C.). These images represent different versions of elephant, deer, tiger, dog, fish, boat, etc. The fact that our ancestors had no standard written form for the idea of these objects, shows that they confused writing with painting. At this point we can fix no boundary between the two arts.

During the reign of the Yellow Emperor there are also records of a more definite form of painting: he commanded to be made a portrait of his arch-enemy, Ch'ih Yu, as a horrible warning to his people, and a means of diverting them from further wars. As an antidote, he also had painted the portraits of two legendary heroes, Shen T'u and Yü Lü, to drive out devils. At this time too, it is said, the Chinese learned the art of dyeing materials.

Under the glorious Emperors Yao (2357-2261 B.C.) and Shun (2261-2205 B.C.), so admired by Confucius, Chinese civilisation and culture is supposed to have reached a kind of legendary Golden Age. Even though we may relegate some of the 'history' of this time to the realm of myth, we can be sure that there was some basis for the stories. Music and dancing were said to have been founded, and bronzes, dyes and so forth were developed.

We are told that the first person to be given the name of 'Artist' was the younger sister of Emperor Shun, a lady by the name of K'ê Shou, but we have no authentic proof.

In conclusion, during the primitive period, the Chinese used engraved marks on stones and metals as aids to memory. Under the Yellow Emperor they began to use colour to dye clothes, while under Shun they also dyed hides and head-gear, as well as engraving bronze vessels for domestic and sacrificial use. The dyeing of garments, of course, may not have had any aesthetic object, but may have served merely to emphasise differences in social rank. On the whole, we can call it a period of applied art.

THREE DYNASTIES (HSIA, SHANG AND CHOU) AND CH'IN, 2205-207 B.C.

With the opening of the Hsia dynasty, 2205 B.C., Chinese recorded history begins, though legend still figures largely in it. We read that it was a time of great forward movement in culture. Government ritual became of first importance for the stabilising of manners in the community, and painting itself was brought into the service of Rites. Nearly every work of art at this time carried some hint of warning or admonition; the painters, under

official survey, had the idea of improving social morality, and of swaying the hearts of the people towards right living. These people were still simple-minded, thralls to superstition, credulous, and incapable of understanding the true nature of the universe. For this reason those in power invented warning fables and worked out a system of ritual, to play upon the simple emotions of the people, and to keep them in fear of their ruler. The artist himself was a kind of teacher and prophet at this time.

We also read that it was for the inspiring of awe that Emperor Yü the Great, of the Hsia dynasty, had bronze tripods engraved with images of devils and gods. Nor was it to satisfy any aesthetic craving that the Prime Minister I-Yin presented Emperor T'ang of the Shang dynasty with an immense panorama of 'Nine Kinds of Rulers'; he wanted to bring his high merits to T'ang's notice—his talent in painting might lead to an increased confidence in his administrative powers.

Later, in the Shang dynasty, we hear of another famous Emperor, Kao Tsung, who had a dream one night about a certain man, under whose wise government the kingdom would prosper. Upon waking, Kao Tsung ordered his dream to be painted, and the picture to be carried round like Cinderella's slipper until this Heaven-appointed Prime

Minister should be discovered. There are other stories of this nature in the annals of our history.

Under the Chou dynasty we read that several officials were appointed to supervise works concerning patterns and designs, for painting could hardly be called an art as yet. One of these was assigned the making of maps of the Emperor's dominions; another the designing of official costumes, royal regalia, crowns, flags and banners, of vases for State ceremonies, and even of gateways to public buildings. But as far as we can gather they were more concerned with order than beauty: they imposed certain forms and colours upon objects to emphasise their real nature, and to guide the people to an understanding of various functions and rites, just as one educates a child's mind with coloured toys.

The latter part of the Chou dynasty was a period of decadence in the ordering of society; the feudal nobles were rising against the royal house and against one another. This led to the period known as the 'Warring Kingdoms', when the leading men of different States competed with one another for the main power in the Empire. There was restlessness and perpetual fighting, but all the while the nobles were respectful to scholars and literary men, since they believed that their reputation would

thereby be greatly enhanced, and their position stabilised. And so Philosophy and Literature developed more freely than ever before; it was, indeed, the heyday of Chinese philosophy. It is natural that painting too should be in the ascendant. Eventually the Emperor who became known as Ch'in Shih-Huang-Ti, the first Emperor of the Ch'in dynasty, took charge of the Empire and unified it once more, establishing the Ch'in dynasty (246-207 B.C.).

The famous, and to some extent notorious, Shih-Huang-Ti took a firm hand with the truculent nobles, and he pressed a large bulk of the population into military service, sending them out to quell disturbances on the outskirts, and to enlarge his boundaries. It was a period of triumphal victories, but there was not much time for the glories of peace, the promotion of Art. However, his Prime Minister, Li Szŭ, created a new style of handwriting called 'Small-Seal Characters' which unified all ancient scripts and which founded the art of calligraphy, sister to our painting. Though he ordered all records of Confucius' teachings and other documents to be burned, this Emperor did bring art into personal service in his magnificent palace, A-Fang-Kung. Unfortunately it perished in flames during the fighting at the fall of the dynasty, and it is sad that this early example of our architectural art

should have disappeared without leaving a trace. We are told that it was five hundred metres broad and long, furnished with countless chambers, ornamental balconies, and pavilions, and that the pillars and roof-beams were miraculously carved with scenes of the proud Emperor's dominions. We are perhaps justified in supposing that since there were carvings in plenty there were also paintings.

If one takes a broad view of the period, one finds that in the time of the 'Warring Kingdoms' the thought of the people was free and enlightened; artists were at liberty to follow their own fancy. Under the Ch'in they both benefited and suffered from a reign of absolute rulers; creative effort was restricted no less than individual thought, but we may be sure that painting was used architecturally.

HAN DYNASTY, 206 B.C.-A.D. 219

The beginning of Han marks an important stage in the development of our art, for it was then especially that communications were opened up between China and other countries of the Far East, especially India and Persia. At this point, although the treatment of our painting felt very little influence from the outside world, the range of subjects increased with the influx of new ideas and experiences.

A second significant landmark was erected besides—'Art' received official recognition and encouragement. There were now people devoting themselves specifically to painting, and to a painting that was the expression of an inner necessity, not the response to an Imperial command. There are some, indeed, who say that Chinese painting only began under the Han dynasty, but one cannot uphold this except in a limited sense—that 'genuine' painting must be spontaneous.

This dynasty is usually marked out historically in two divisions—Former and Later Han. The first was inaugurated by the Emperor, Kao Tsu, who had been merely a simple, poorly-educated civil servant in a rural post, but who was served by able ministers. Unlike the House of Ch'in, far from suppressing Confucius' teaching, the former Han emperors made great efforts to revive and spread it. Unfortunately, their ministers' insistence on Confucian ritual was too rigid, and there was much countervailing restlessness throughout the country. Though we may not say that Lao Tzŭ's teachings of quietness and satisfaction through inward peace actively controlled the practice of our Han painters, we may safely suppose that from this time onwards Taoism began to influence the creative mind. Some part of the population realised that there was a permanent

satisfaction to be found outside the domain of affairs, and turned to a free employment of their thoughts and talents: Emperor and Sage together fostered the development of painting at this period.

Ornamental palaces were popular with the early Chinese Emperors; Han Wên-Ti or Emperor Wên of Han dynasty named his palace 'Infinite Happiness', and, like his predecessor Ch'in Shih-Huang-Ti, had it beautified with artists' work. Portraits of various virtuous officials were painted on the walls, and a special banner designed with symbolic images to indicate that beneath it the Emperor would sit to receive the advice of his faithful people.

Han Wu-Ti or Emperor Wu of Han dynasty of glorious name, who drove the Western tribes out of Kansu and found a route to India, instituted a kind of Royal Academy; he had a special pavilion built for himself, in which to collect all the most highly praised paintings and writings from every part of the kingdom. Han Hsuan-Ti or Emperor Hsuan of Han, on the other hand, had apparently been fortunate in his Prime Ministers and commanded all their likenesses to be made and hung round the walls of the Hall of Unicorn. In the time of Yüan-Ti or Emperor Yüan, one of the successors to the Han throne, the Court painter, Mao Yen-Shou, specialised in ladies' portraits, and

would present paintings of the Palace ladies to
the Emperor at his request.

The Later Han (*c.* A.D. 25-219) is associated
with the spread of Buddhist thought in China.
Scholars think that its first introduction to the
country from India was no later than the early
years of the Christian era, and it may be
that the great missionary King, Asoka, who
reigned in India from 264 to 228 B.C. and who
sent his Buddhist messengers into all parts of
the known world, may have sent word to
China at that time to tell us of salvation
through Buddhism. It is possible that all
records perished in the first Emperor of Ch'in's
general conflagration. Although we can have
no doubt that the Chinese had an earlier
acquaintance with Buddhist doctrines, we may
believe it was under a Later Han ruler, Ming-
Ti, or Emperor Ming, that our artists and
sculptors began to use religious subject-matter
of this nature. There is a popular story con-
nected with Ming-Ti which may possibly have
some root in fact: it is said that one night he
dreamed of a golden image of surpassing
majesty and dazzling splendour, and that there-
after he could not rest until it was found. He
sent his messengers out in search, just as the
Jewish Herod sent the Wise Men to find the
Christ-Child, and with no more reasonable
guidance than a star. Eventually a certain

T'sai Yin, having penetrated the borders of India, returned to the Emperor's court with a portrait of Sakyamuni—the latest incarnation of the Great Buddha—and a following of Indian Buddhist monks who could depict the stories of His life.

Ming-Ti had already established a kind of artistic caste, offering official standing to those who manifested genuine talent. He now enjoined upon them to paint Buddhist subjects under the teaching of these newcomers, and so it came about that Buddhist painting began its existence as a separate genre in China. Naturally at the outset it was Indian in character, but as the thought was assimilated and modified by the national mind, so the painting and sculpture rapidly took on a purely Chinese appearance.

Besides adopting specifically religious subjects Later Han painters continued the tradition of portraying ancient Emperors and heroes of old times for the edification of their own generation. There was already a body of accepted literature, and the artists seem to have referred increasingly to it for subjects. Thus it was that professional artists came into contact with scholars, while at the same time the scholars themselves learned to paint. Among the most famous scholar-painters are T'sai Yung and Liu Yü, both of them literary

men, painters, and high officials. We should notice, in view of the later developments of Chinese painting, that this was the point at which it began to move away from the domain of the technician to that of the man of letters. Under the Han dynasty true painting came to birth. In spirit it enjoyed the free life of the imagination; in subject it continued on the lines of its forerunners, while at the same time entering upon a new field dominated by religious motifs.

SIX DYNASTIES, A.D. 220-588

These years included a period when the country was again suffering from one of its periodic and apparently inescapable disruptions. There was no single ruling house; we put the general title of 'Six Dynasties', after the six main houses of Wei, Chin, Sung, Ch'i, Liang and Ch'ên, to the whole stretch of time, but this title must be geographical rather than historical, contingent upon the temporary dominance of a princely family in one particular district of China.

One may well imagine that at such a time, good order in society would fail; that Rites and Manners would be disturbed, and that people would eagerly turn to religious comfort. As peace was made in one part of the country so

disturbances broke out elsewhere; the officers wearied of planning strategies and the soldiers of service, the population was exhausted by continual forced flights; it seemed that nowhere could peace be found but in a Place of Quietness built in the mind by devout followers of Buddha or Lao Tzŭ. Here you may observe that religion has never been a natural instinct with us as it seems to have been with most other nations of the world: we turn to it for relief when natural philosophy fails us and the circumstances of our lives become unbearable.

Painting was very deeply influenced by this movement in national thought: historical subjects now gave place to religious; banners were covered with figures of the Great Ones and hung on temple walls for worship, or else the walls themselves were adorned with frescoes of similiar nature.

As I have said, Buddhist art was introduced from India, and the subjects were stereotyped following popular demand, but there were three Chinese painters at least during this period who through their unfettered genius broke the confines of foreign domination and produced some truly national masterpieces. They were T'sao Pu-Hsing of Wu kingdom, Wei Hsieh of Chin dynasty (25-419 A.D.), and Wei Hsieh's disciple, the more famous Ku K'ai-Chih. The last named painted ordinary people

as well as Buddhist figures, with delicacy, humour and great technical mastery. He also started to paint landscapes. His brush-strokes are living, his sense of movement rich in grace; he indeed began a new era by the humanising of figure-painting and the introduction of land-scape—a type which rose to the highest degree of significance in later times.

At the time when the Chin dynasty was driven from its stronghold by Northern barbarians and the original Chinese race (the 'Han Men') was settled in the South, the theories of the Taoist philosophers Lao Tzŭ and Chuang Tzŭ came to the forefront and at last predominated in both painting and general thought. We Chinese have an inborn love of our wild, mountainous scenery, and Taoism, which emphasises the following of Nature and the free life of senses and mind, easily turned this love to worship. Painters shared the passion, and landscape art, once having sprung, grew to a flood, and has never since abated. At this early date it was still mainly evident in backgrounds, but from Ku K'ai-Chih's essay, 'On the Painting of Cloudy-Terrace Mountain,' we conclude that he at least, though perhaps once only, was a landscape artist pure and simple.

This time, indeed, marks an important transition between the older historical and religious

figure-paintings and the full flower of T'ang landscape and portraiture. After the Chin dynasty fell (*c.* 419 A.D.) there was both a Northern and a Southern dynasty. At this time conditions of living were alike difficult in both extremes of China, with the result that North and South tend to show the same marks of religious faith.

Under the Southern dynasty there lived and worked the nature-lover and nature-painter, Tsung Ping of Sung (420-477 A.D.)—a hermit mountain-dweller, Taoist, and to some extent mystic. He tried to discover the secrets of the wind, the flowing water and floating clouds, and to transfer his vision to paper and silk, but he failed to hand on his discoveries. His works are attuned to that mood of still, religious ecstasy which we associate with the Taoist faith. In the Ch'i dynasty (479-502 A.D.) China was fortunate in the birth of a great art critic and figure-painter, Hsieh Hê. It is said of his skill in portraiture that he had only to give a hasty glance, and immediately he could set down an exact likeness. The 'Six Principles of Painting' were formulated by his penetrating mind. They represent the standards against which any painting should be measured, and so satisfactory are they to the Chinese that they have remained to the present day, unaltered, unsupplemented, almost

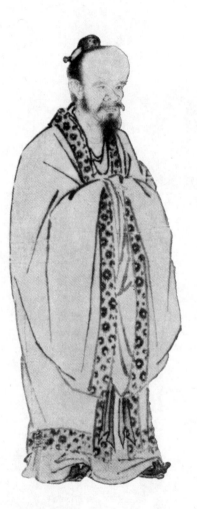

I PORTRAIT OF CONFUCIUS Ma Yüan (Sung)

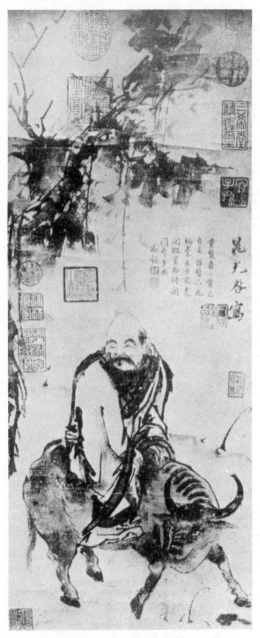

II LAO TZU RIDING ON AN OX
Ch'ao Pu-Chih (Sung)

uncriticised. Naturally some of the ideas they contain were already in existence in the theories and practice of earlier painters, but they were unsystematised until he came. There has been some discussion as to the best English translation: it is remarkably difficult to find an equivalent of his terms in a foreign tongue, since the inspiration and technique with which they are concerned are themselves alien. Here is a literal version: Rhythmic Vitality, Structure and Brushwork, Modelling from Object, Colouring Adaptation, Careful Placing and Composition, Imitating and Copying.

Although little has survived of his own paintings we must acknowledge that in the matter of theory Hsieh Hê made a great contribution to art.

It was under the Northern dynasty that the justly famous Rock-shrines of Yün-Kang and Lung-Mên were adorned with Buddhist sculpture. Both groups are vast conceptions; the complete mountain flank is intersected with grottos carved in the living rock. Each contains an image or images of the Buddha attended by ministering Beings; those at Yün-Kang in particular show pieces more impressive and solemn than any other Buddhist works extant in China. By the presentation of these sculptures, the Donors, weary of mortal life where peace and satisfaction were not to be found, desired

for themselves and their relatives an ultimate freedom from the pain of re-birth in the Triple World of Desire, Form and Formlessness.

Although Buddhist paintings were of widespread interest to people at this time, there were also Taoist believers who in their effort to promote their own Faith imitated the Buddhists' methods and even imagery in their paintings and sculpture. Taoist and Buddhist art had thus a parallel development in China during this period.

In conclusion, under the Northern and Southern Dynasties figure-painting reached the highest point of development, and landscape art came into its own. Most of the painters were also scholars well versed in theories of art; they realised the main principles of painting, and tried to turn these principles to the service of their own inspiration. It was a time of free development of mind.

SUI DYNASTY, A.D. 589-617

During this short space of years China was once again united under a single ruler, and, significantly enough, painting from North and South also came together under one school. Religious subjects continued to be painted, particularly in the form of frescoes; nearly every prominent artist of the Sui seems to have tried his hand at these. Monks came

from India and Turkestan, bringing with them paintings in illustration of the customs of their country. The fashion for imitating these new subjects spread widely among Chinese painters.

The Emperor Yang of the Sui dynasty was one of the most extravagant and lavish rulers we have ever had. He ordered many beautiful palaces to be built, employing all the finest architects in the kingdom, and covering the buildings with the most exquisite decorations conceivable. The most remarkable one was called 'The Two Mysterious Terraces', and was divided into two parts: the eastern side was termed 'Mysterious Calligraphy', where many masterpieces of calligraphy were housed, and the western side 'Treasure Traces', for the great paintings. It was our first real National Collection. By great misfortune, most of these treasures were destroyed when the Emperor was making a journey with them to Yangchou, and the boat containing many of them sank in the river. After the fall of the dynasty the remnants were scattered and came into the hands of private collectors. Emperor Yang himself seems to have been a prolific art critic; he is reputed to have written fifty volumes on 'Ancient and Modern Art'.

There was a marked tendency towards theorising on the part of the landscape painters

during the Sui, and at this point the upholders of opposing schools in the north and south seem to have united: this marks an important landmark in our artistic consciousness. Nor can we doubt, since we have so many records of their discussions, that the Sui painters also practised widely the art of depicting the beautiful scenery of their country.

T'ANG DYNASTY, A.D. 618-905

Since the fall of the Han dynasty, three hundred years before, there had been no continuous peace or unity in China, and there could be no systematic development of painting; a few works of isolated genius were created, but there was no steady flow. The short Sui dynasty began the work of unifying which T'ang completed; the early T'ang Emperors governed with wisdom, sorted out discordant elements, enlarged their territory in the direction of Canton in the south and India in the south-west, and brought calm and contentment at length to their suffering people. Now scholars could work regularly; literature, art, and religion grew in strength everywhere.

At the outset artists tended to follow the traditions of Wei and Sui; religious subjects still dominated and landscapes imitated the style of the Old Masters. As for figure-painting, this too followed well-trod paths: the first

Emperor of T'ang, like so many Emperors before him, would command his artists to commemorate his victories upon scrolls and to paint the portraits of generals and high officials, who on his behalf had won outstanding successes. The brothers Yen Li-Tê and Yen Li-Pên were the most famous figure-painters of this time.

The second T'ang Emperor T'ai Tsung claimed the sage Lao Tzŭ as his ancestor and this naturally gave prominence to Taoism; together with Buddhism it continued to flourish as a subject of art.

At the accession of the Emperor Hüsan Tsung there began a glorious age in Chinese culture, known as the golden age of T'ang. The creation of poetry and painting reached undreamed-of heights. Up till now, the painters had favoured a style of brush-work that was scrupulously detailed, smooth, precise; the general feeling of their productions was one of loftiness and dignity. There now began a kind of Renaissance of Chinese painting; new styles and new types of brush-work sprang up almost overnight; the creative mind was on fire, and in the power of its own dæmon—not of tradition. The Emperor himself was a talented painter and calligraphist; it is said that he invented the now familiar stroke for bamboo painting through having seen a spray outlined

on the thin paper of his window-panes when his chamber was all dark and the moon brilliant in the garden.

The greatest names associated with the period are those of Wu Tao-Tzŭ and Li Szŭ-Hsün. The first is not only noted for the glory of his Buddhist and Taoist figures, but it was he in particular who changed the old style of land-scape-painting to one of bold, powerful line and movement. His pictures give the impression of a sudden storm rising, with thunder and lightning in its wake.

Li Szŭ-Hsün, however, still adhered to the old precise and laborious method, though the spirit was a fresh one: he was the greatest colourist of his time. He was also the founder of the so-called Northern School of landscape, a school which continued through the Five Dynasties and up to the present day. Among its chief characteristics are severity of form, detailed workmanship and emphasis upon balance of design.

The story is told about these two artists, that they were both commanded by the Emperor Hsüan Tsung to paint for him some scenery of Chia-Ling River along the Upper Yangtze. Li Szŭ-Hsün began immediately and for three months worked with brush, ink, and colour; at last the picture was complete. Wu Tao-Tzŭ meanwhile waited long for

inspiration, and at length on a day when the scenery appeared to him more beautiful than ever before, he took up brush and in the full light of vision recorded his impression in a single day. You might expect, as in the fable of the hare and the tortoise, that the Emperor would applaud more highly the one who had laboured so long, but art cannot be judged by moral standards; Hsüan Tsung praised and rewarded them both equally!

The founder of the so-called Southern School of landscape was Wang Wei, whose new and individual style was based upon a use of ink and water, with occasional light colouring, in contrast with the richly coloured paintings of Li Szǔ-Hsün. With this painter we enter upon the 'mid-T'ang' period, rather different in character from the 'early' and 'glorious' T'ang. The Meditative School of Buddhism, with its great emphasis upon philosophic speculation and the inward-turning of the spirit, led men to rely no longer upon the efficacy of public rites but upon personal enlightenment through quiet contemplation. Wang Wei was typical of his time; besides being a Buddhist believer and a philosopher he was a good friend of mountains and streams, forests, poetry, and the lute. His was the type of character chiefly admired—cultured, thoughtful, and religious. In him the various aspects of life found perfect

expression; art, poetry, and goodness, for it is a well-known saying that 'his pictures are poems and his poems pictures', and an acknowledged fact that he preferred a peaceful meditative life in the mountains to a successful worldly career.

In the course of these times the manner of the literary man and painter grew increasingly cultured and refined, and the two forms of art often met in the same person; eventually the 'Wên Jên Hua' was established; a school of painters whom I may call in English 'Scholar' or 'Literary' artists.

At this point, landscape definitely took precedence over every other type of art in China, a position which it has kept ever since; but as it owed its origin largely to religion, a desire to escape from the world into a state of spiritual freedom, so landscape painting has never entirely lost its religious character. Scenery was now painted on the walls of the monasteries and temples, together with Buddhist and Taoist images.

Under the 'Later T'ang' the inspiration of literary men dwindled somewhat; thought and creative work tended to run in channels already carved by foregoing artists, or else to run off in narrower side-tracks. Painters were fond of specialising in one small branch, such as bamboos or chrysanthemums. Horse-painting was

extremely popular; many species of horses were presented to the Emperor as tribute from neighbouring countries, and the painters seem to have found a fresh subject for expression in these new types of a familiar animal. Han Kan was the most renowned among them, and we can hardly find any painter of horses in later times who has excelled him in this branch. Flowers, birds, animals, and insects are really the speciality of Sung painters, but in the last years of T'ang there were already some hints of the glories to come, especially in the works of Pien Luan and Tiao Kuang-Yin.

Taking a long view of the whole T'ang period we see literature highly developed, and given expression by a host of brilliant poets and writers. Many of them wrote in honour of art and artists—discussed, criticised, appreciated, thus bringing painting increasingly into the public eye. In painting itself, the brush moved with a freer rhythm after the severe constraint of the Chin style; colouring, touch, and composition were governed more and more by an inner vitality—what one may call 'rhythmic vitality'—and this is evidenced in both landscapes and figure-paintings.

To the greater richness of the artistic harvest, painters broke away from a faithful imitation of the Ancients and created their own styles, letting their works stand on their own merits

and compete with one another. Thus it was not only necessary to have a mastery of technique, but also the ability to express freely an individual idea; the artists' knowledge, thought, personality, mental equipment were all embodied in their works, whether they chose to depict a spray of Plum-blossom or a vast panorama of rushing waters. The expression of a painter's inner spirit had come to be the first essential of a good work of art, and in their effort to give palpable form to this ideal the T'ang men made perhaps the greatest mark on the page of Chinese Art history.

FIVE DYNASTIES, A.D. 905-960

Once more, after the long unity of T'ang dynasty, the country was split up and ruled in part by alien races. Painting varied in different districts; for example, in the kingdoms of Wu and Yüeh, Buddhist and Taoist subjects predominated, while in Western Shu and Southern T'ang, birds and flowers were more popular than anything else.

T'ang art had reached the zenith of its achievement, and there was likely to be a slight falling back, especially at a time of political disturbances. Landscape, however, showed some developments. The increased influence of Taoism brought greater concentration than

ever upon landscape painting, together with bird, flower, and other such paintings, at the expense of figure-painting. The Taoist hermit Ching Hao and his pupil Kuan T'ung were two outstanding exponents. They inaugurated a powerful and direct style of depicting scenery, in which the methods of Ku K'ai-Chih, who had used landscape merely as a background to his figures, were superseded.

Flower and bird painting was a prime favourite at this time, and a variety of fresh styles were invented to advance an art that the Sung painters were to bring almost to perfection in their own manner. Hsü Hsi and Huang Ch'üan were the most prominent exponents of this type. The latter evolved the method of treatment which we call 'Shuang-kou' in Chinese, 'Double-lined Contour', while the son of Hsü Hsi, Hsü Ch'ung-Ssu, created a form called 'Mo-ku', 'Without Bones', somewhat resembling European water-colour—volume in place of line. These two types of treatment have continued up till the present day.

It is interesting to note, in conclusion, that the walls of temples and monasteries were now adorned not only with religious figures, but with stories of human life, myths, landscapes, and even single trees, birds, and flowers. We can see how art is not only approaching literature, especially poetry, but religion as well.

SUNG DYNASTY, A.D. 960-1276

Painting underwent a great change in China in these years, being chiefly distinguished for its literary character. Figure-painting and religious subjects lost their importance somewhat, while landscape and especially bird and flower paintings took their place. Many of the Emperors were themselves artists, and this may account for the considerable Court patronage that was accorded Sung painters. Artists seem to have been treated with more respect and distinction than ever before. The Academy, which flourished to a limited extent during the T'ang dynasty and was carried on through the difficult times of the Five Dynasties, was now organised on a much larger scale. The Emperor Hui Tsung, himself a good painter, wished all his court officials to be artists.[1] He it was who added painting to the requirements of a would-be official; the Palace examination now included the illustration of a line or phrase from the Classics or a well-known poem. Thus the thought in a painting

[1] See Plate IX. The Emperor specialised in 'Bird and Flower' painting, but here we see an example of his landscape, 'A Cloud-capped Hill on a Fine Morning.' You will remark that though the strokes are fine and precise, the scene realistic, in keeping with the best Sung traditions, the painting is not overlaid with detail: it gives us the impression of a quiet, cultivated mind.

became the most important element rather than touch or faithfulness to nature. A painter would express poetic feeling through his brush, and sometimes of his own free will look to poetry for a subject; the purposes of the brush and of the written word were then in some respects almost identical. We find many a famous artist, such as 'Sleeping-Dragon' Li and Su Tung-P'o, who were both painters and men of letters. These two often used to meet over the wine-cup to discuss and criticise painting, talking all through the night, in some lonely pavilion perched in the mountains. Out of their close friendship, or perhaps merely from playfulness, they formed the precedent for a type of painting we still practise occasionally—that which is termed 'Co-operative'. They have a well-known picture of 'Pine and Rock', on which Tung-P'o's younger brother Su Tzu-Yu has inscribed the short poem:

'Tung-P'o himself formed the jagged rocks,
He left the long pine for "Sleeping Dragon".'

Even to the present day we keep this habit of sharing our talents occasionally.

Following the achievements of their predecessors, the Sung artists made further developments in painting styles. In landscape, though most painters walked in the steps of Wang Wei, Ching Hao and Kuan T'ung, two of them, Ma

Yüan and Hsia Kuei, founded an altogether new style, through discovering the secret of a different type of brush-stroke. You will notice from the former's picture, 'Ferrying on the Yangtze River' (Plate XIII), that in the treatment of the rocks especially, a broad, bold touch has been used, markedly contrasting with the fine, delicate brush-work usually associated with the Northern School of Landscape: in general effect, one may compare his style with a European chalk sketch as against a fine etching. Ma Yüan, also of the Northern School, used the same type of stroke—we now call it the 'Axe-cut'—but his most important innovation is in the Composition. The typical T'ang and Sung landscape takes in a complete mountain peak, many miles of winding river, or a great expanse of forested hill-tops. The artist packs his composition with detail, each stroke neatly placed, firm, and disciplined. But Ma Yüan and Hsia Kuei discovered how empty space could be put to use. With more powerful and less numerous strokes Ma Yüan would paint a small pile of rocks or a few yards of winding stream, and with the sparest detail and the simplest composition, achieve transcendent loftiness of feeling. Landscape painting reached its peak in the Sung period.

Zen Buddhism flourished in the mid-T'ang period, when its acceptance by scholars and

artists effected its assimilation with the native
concepts of Taoism and Confucianism. Thus,
while purely religious subjects are compara-
tively rare in Sung art, many of the landscape
paintings include figures which could be Con-
fucian scholars, Buddhist converts or Taoist
hermits equally well. These paintings breathe
harmoniously the air of three different schools
of thought.

Although every type of subject was repre-
sented during this fruitful period, we must
admit that the greatest achievement was in
'Bird and Flower' paintings. Usually they were
coloured, and of exquisite and delicate work-
manship, brushed on to fine silk.

It was chiefly in Sung that the fashion for
painting as a hobby spread among literary
men: the four plants, plum, orchid, bamboo,
and chrysanthemum, which we term the 'Four
Gentlemen', were often chosen for their sub-
jects, to express their 'gentlemanly' character
to the world: a new style of painting orchids,
without colour, was invented at this time.
We call this hobby 'Pastime painting'; and
although the pictures themselves may have had
no outstanding merit, at least they deepened
the artistic consciousness of the people; they
give an indication of how far Sung art was
moving in the direction of literature.

Indeed, it was a period when the Southern,

the 'Literary' School, far outweighed the influence of its Northern rival, threatening it at times with extinction; even religious paintings came under the sway of literature.

Metaphysics occupied the minds of most men of culture in the Sung dynasty, and even dominated painting; the painters were particularly concerned with seizing the significance of Form in objects. For this reason painting may be said to have grown realistic, but at the same time, Form was impregnated with philosophical Idea, and it became the goal of the artists to evoke the indwelling spirit of the images they painted and to harmonise it with their own spirit. This introspective, individualistic tendency was further fostered by the prominence of theoretical writings on art, and analytical discussions among the painters themselves. More than at any other time, Sung paintings may be found to express the artist's own thought.

All this time, trade-relationships were being formed with East Turkey, Persia, India, Japan, and Korea, and works of art from these countries were filtering more and more into China, with new ideas and treatments to enlarge our critical capacity, if not to influence our art directly. Korea had already known a semi-Chinese culture, for she had been conquered by the T'ang Emperor Kao Tsung in

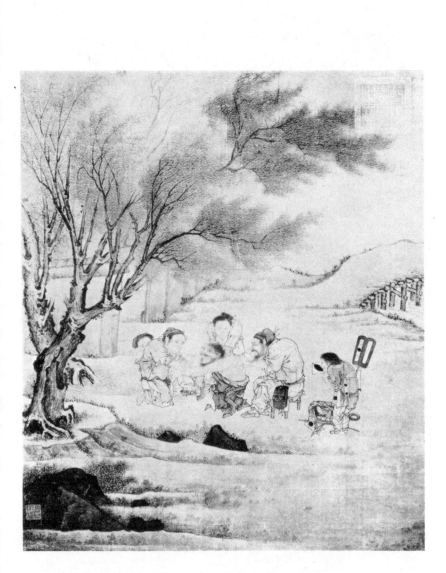

III THE PHYSICIAN'S VISIT Li T'ang (Sung)

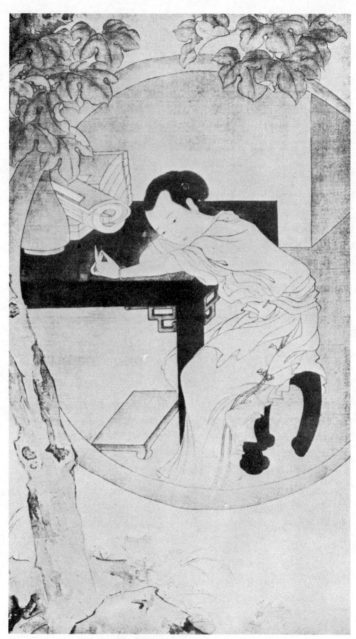

IV 'HORS DE COMBAT' Ku Yün-Ch'êng (Ming)

A.D. 667-8. Now in the Sung days the King of Korea sent many of his artists over to China to learn the painting style which he so much admired. Li Ning was perhaps the most successful; after adapting himself to the Chinese art ideals, he became a Court painter to the Academy. Japan, although further from China than Korea, had communicated with her since the Han times. During the Sung dynasty many masterpieces of T'ang and Sung art were bought by her in emulation of our culture. The Japanese also learned to paint in the Chinese style, mostly after the manner of the Northern School. Hsia Kuei and Ma Yüan were their favourite models. But the imitation is never so good that we ourselves cannot distinguish the brush-work: however bold and free the stroke of a Chinese Master, we can feel behind it years of training in calligraphy and brush-control.

YÜAN DYNASTY, A.D. 1277-1367

During the Yüan dynasty, the government was no longer in the hands of people of Chinese blood, but of the Mongols; political policy underwent a change, and to a certain extent the thoughts of society moved with it; the artist followed in its wake. On the one

hand 'pastime painting' spread considerably, especially among cultured men who kept out of politics and had a private distaste for the new order. On the other, those who curried favour with the Emperors found their thought being confined and driven into channels too narrow for it or altogether alien. Those who wished to be acceptable to the Academy had to follow the Royal taste: but the Mongol rulers, after a vain effort to understand the Chinese culture, abolished the Academy altogether, and gave very little patronage to artists. With the upper ranks of society failing to promote art, it fell to scholars and thoughtful people to keep the flame alive; it is not surprising that the 'Wên-Jên-Hua' or 'Literary School' came into special prominence at this time. Its characteristic was lyrical feeling, its exponents men of learning and taste. Whatever the subject, whether landscapes, figures, insects, birds or animals, these painters did not need to draw from nature; they looked within themselves and drew forms from imagination. Indeed, they were not concerned with Form as such, in contrast with the Sung painters, but chiefly with expressing vividly either their grief and suffering at the times, or their complete indifference to worldly affairs. It was an impressionist, idealist Art, seeking above all things to

bring out the 'rhythmic vitality', almost despis-
ing the meticulous care which the old masters
had expended upon brush-work.

This style, which we may call simple and
sublime, was the invention of a few scholars at
the beginning of the dynasty, but gradually,
having been extensively imitated, it became
typical of the whole period: the fashion grew
to paint only the simple. Five prominent
names associated with it are those of Kao K'ê-
Kung, Huang Kung-Wang, Wang Mêng, Wu
Chung-Kuei and Ni Tsan (or Ni Yün-Lin).
Each, however, created a style of his own; the
last named portrayed landscapes with a few
dry, free strokes, seldom coloured, and without
the contributive interest of figures, while the
others generally used slight colour.

We say, too, that the Yüan Masters alone
learned the secret of harmonising ancient and
modern ideas; they seemed able to extract
some essential points from the paintings of
former ages, and to conform or synthesise
them with modes of their own day.

In the later years of the dynasty, landscape
art seems to have come to a standstill; or per-
haps we may call this last stage the extreme
refinement of landscape painting. Now the
painters said they were 'writing' their thought
rather than painting it. If you understand the
relation between painting and calligraphy in

China you will visualise the type of picture this description would fit. The famous calligraphist and painter Chao Mêng-Fu once wrote,

'Painting and writing are fundamentally the same; to paint a rock is to write in the Fei-Pai style; to paint a tree is to write in the Chou style. If you want to write Bamboos you ought to be familiar with the Eight Styles of Calligraphy.'[1]

The Yüan artists termed this bamboo-writing, rather light-heartedly, the 'Ink-game', and amused themselves with it in the falling days of the dynasty, when Court patronage was lacking.

MING DYNASTY, A.D. 1368-1643

Every branch of painting had by now reached full development; what remained but to follow in the steps of forerunners? Ming dynasty works all tend to follow the styles of earlier times with only minor modifications. After the lean days of the Yüan dynasty,

[1] 'Fei-Pai' means literally 'flying taffeta', and takes its name from the flowing sashes of dancing girls, which in the motions of the dance seem to curl and sweep in the air like birds in flight. The term was adopted for a style of calligraphy, where the movement of the brush appears to follow the curves of folded silk. 'Chou' is the name given to the earliest form of Seal writing, very strong, definite and regular in the strokes. The application to rock and tree painting may easily be visualised.

however, the artists were once more in Court favour, though at first they had to tread warily, for the first Emperor, Hung Wu, shared the propensities of an 'Alice in Wonderland' duchess! He was something of a painter himself, and prided himself upon his discriminating taste: those who enjoyed the supreme felicity of his patronage must fall in with the Imperial ideas or run the risk of execution. Posterity, out of range of the terrible axe, does not agree with Hung Wu, and finds very little of permanent value in early Ming paintings.

The artist's life and manner of expression were still suffering from a form of tyranny under the fifth Emperor, Hsüan Tsung. There is a significant story told about him and a certain painter, Tai Wên-Chin. The latter presented His Imperial Majesty with a landscape entitled 'A Lonely Fisherman on an Autumn River'. But the fisherman was wearing a deep red robe, and as the royal advisers pointed out—this colour indicated the dress of a certain rank of official; and how could an official be fishing in his uniform? 'Very true!' replied the Emperor, and the painter was dismissed from Court.

Others had better fortune: Shêng Mou and Lin Liang followed an old traditional style, with some individual modifications, and attained a high degree of fame. As time wore

on, the dynasty began to degenerate; there were invasions from neighbouring tribes, and disturbances from within; the Court domination of culture weakened. Artists rose up from among the scholar classes in opposition to the Academicians and a great storm of rivalry burst upon the artistic world; out of the clash rose a minor renaissance.[1] Portraiture, scenes from history and from social life came once more into favour after a long eclipse. Ch'iu Ying's is the name chiefly associated with this genre in the Ming dynasty, and his work was considerably influenced by T'ang figure-painting. T'ang Yin is another noted name.

As the country was torn increasingly by wars in the last years of Ming, many artists

[1] Our Academy came into existence in the sixth century A.D., and we have early products of the two Schools, which I may call the 'Academic' and the 'Non-academic', but we cannot say that up till now there was any real conflict between them, or that the conflict at this point lasted for long. The Court painter found sufficient room to expand his talents in the somewhat limited atmosphere of the Palace, and under his Emperor's command, while his brother felt the bands of constraint too strong and preferred to keep away from the Court and follow his own inclination: the one took the high road, the other the low road. At almost every period they tolerated each other. Nor are we in the habit of praising one at the expense of the other. By religion we can be Confucian, Taoist and Buddhist at once; in art e give our love and admiration to masterpieces of both Schools equally.

escaped to the comparative quiet of Japan. There Japanese art underwent a renaissance through the infusion of Chinese inspiration, and the actual practice of Ming artists. The monk I-Jan was the most prominent proselytiser.

Although we must admit that the Ming painters propagated the old rather than planted new seeds, the harvest was not without glory.

CH'ING DYNASTY, A.D. 1644-1911

This again was a non-Chinese dynasty; the conquerors of decadent Ming came from Manchuria. They were anxious, however, to assimilate the pure Chinese culture, and were far more successful in their efforts than the Yüan Emperors. The first members of the Ch'ing House to occupy the 'Dragon Throne' tried eagerly to win the people's will by fostering traditional scholarship and art. Officials were sent to all parts of the kingdom to summon learned men to the Court, and so it came about that many a time ambitious artists betrayed their talent for the Emperor's favour. A great deal of artistic ability was squandered in striving for success in official examinations, and political views were as important as the divine spark. But in China there will always

be some who have no interest in public affairs, and who prefer the cool air of the mountains. Taoist insight is the real source of the intense delight which Chinese poets and artists take in the natural formations of their mountains, rocks and rivers. They lived in the world they created.

There are four well-known painters of the early Ch'ing, whom we generally term 'The Four Wangs', for although they were not of the same family, they share a surname—Wang Shih-Min, Wang Chien, Wang Shih-Ku and Wang Yüan-Ch'i. None of them was an original artist; they were all, as Confucius said of himself, 'Transmitters', and followed the good painters of the T'ang, Sung, and Yüan, with the exception of Ma Yüan and Hsia Kuei: thus the Southern School style predominated through them. Wang Shih-Ku was the most prolific of the four, perhaps of all our artists: he produced a countless number of works of every type and manner. Our example in Plate XV is a little after the Sung manner—the stroke fine but firm, the trees and waterfall realistic; the composition is simplified, however, reminding one that the painting belongs to the art traditions of more modern times. The general impression we have of this painting is typical of the period: every possible variety of manner seems already to have been tried.

The time of the Emperor Ch'ien Lung pro-
vided a gleam of lightning: his was the most
glorious reign in the whole dynasty, and though
his taste may have been dubious, the Emperor
was certainly generous in his patronage of the
Arts. He collected masterpieces, even sup-
ported artists who worked outside the super-
vision of the Royal eye, and encouraged the
growth of the humbler arts, such as pottery,
and very rich and elegant painting materials.
(See Chap. VIII.)

After Western Catholicism and Protestantism
had been introduced into China a certain
Italian priest and artist, Castigleone, who was
given the Chinese name of Lang Shih-Ning,
became a court-painter and invented a new
type of art using Western methods with Chinese
brush, ink and colour. The technique was
skilful, and the result realistic; for a while his
innovation was all the rage, though the real
connoisseur remained aloof. Lang Shih-Ning's
most prominent contemporary follower was
Chiao Ping-Chên.

Meanwhile many of our old masterpieces
found their way to European or American
collections; it would have grieved our ancestors
to see their descendants handling money in
return for works of art: some artists began to
paint for profit. The process was an inevitable
one as soon as our nation had come into

contact with the outer world, and become a part of the great international system of politics and economics.

There were still a few artists whom the new contacts stimulated rather than dominated, and who invented fresh styles in the Chinese manner. In the early days of the dynasty there had been two interesting innovators, Pa-Ta Shan-Jên and Shih T'ao, who may really be termed 'Revolutionists' in our art history. They adopted a manner freer than ever before, left both ancient tradition and modern influence to care for themselves, and danced, so to speak, to their own piping. They did not limit themselves to one 'genre', but chose their individual stroke and applied it to landscape, figures or small natural objects. 'Freedom!' was their battle-cry, and yet it was not an undisciplined licentiousness of the brush; we may be certain from the sure and lively nature of their strokes that they had been well-grounded in the old masters. There is a story told of the French artist Henri Matisse. After his early art training at the Ecole des Beaux Arts, he used to spend his days in the Louvre, copying the masterpieces of Raphael, Poussin, Chardin and the Flemish School. Eventually he felt the need of finding an individual mode of self-expression, not like the old masters, and yet not like the fashionable

'Impressionists'. One day his teacher, Gustav Moreau, asked him:

'Well, what *are* you looking for?'

to which he replied:

'Something which is not in the Louvre, but is there', and pointed to some barges moving on the Seine.

We may suppose that Pa-Ta Shan-Jên and Shih T'ao were not unlike Matisse in their diligent study of the old methods, together with a desire to strike out a new pathway with a natural, living manner for its main characteristic. Plate XXI, an eagle, gives us an example of Pa-Ta Shan-Jên's work, with its free and sure touch.

In the illustration of Shih T'ao's 'A Snow Scene' (Plate XVI), the title, the components, do not depart from tradition; like Wang Wei's scene of so many centuries before (Plate VIII), there are mountains, some bare trees, a hut or two, a small bridge, but what a stream of idea and experience has flowed between them! Shih T'ao's composition is reduced to bare essentials, his touch free and yet in the firm grip of an inspired mind and disciplined hand. The wash in the background reminds one very much of Western water-colour painting.

Nowadays we consider these two artists, Shih T'ao and Pa-Ta Shan-Jên, the greatest

artistic minds of the whole dynasty, and their work has had an incalculable influence upon our present-day practice.

During the Ch'ing dynasty, Chinese art continued to flourish in Japan and to exert a powerful influence upon the native painters there. If one speaks of the Southern School of painting in Japan one would always remember the Chinese artist Ta P'eng, who so signally impressed his ideas upon it at this time. There were others too—Shên Nan-P'in (Shên Ch'üan), the Bird and Flower painter, Yüan Chi for Bamboos, Ch'ên Hsien and Fan Tao Shêng for Buddhist figures—who were all in high favour with the Japanese. During the last thirty years we have produced two other great artists, Wu Ch'ang Shih and Ch'i Pai-Shih, whose works have also found their way into many Japanese collections.

Since we adopted Western systems of education, painting has been taught in schools as a part of the curriculum. In a number of our great cities, also, art schools and colleges have been established to train young artists. Nowadays our people are being taught the methods of both Chinese and Western painting, while on the other hand the practice of traditional art steadily continues. It is something quite remarkable that in spite of many sporadic efforts to introduce foreign styles, public taste

in China even to the present day still prefers the traditional Chinese styles. Many of our modern painters have made strenuous efforts to harmonise Eastern and Western ideals. Their success and achievement time will prove.

PAINTING AND PHILOSOPHY

In my historical sketch I have indicated how our paintings, particularly the lines of thought they follow, have been influenced by the political and social environment. 'Painting' in China may almost be a synonym for 'Culture', so closely are its rise, progress, and tendencies in touch with the common thought of the times. It began by responding to political demands, then, later on, it followed the real governors of society, the political and moral philosophers; eventually it begins to provide a philosophy of its own. I want, in this chapter, to indicate the main concepts laid down by our Chinese thinkers, and to what extent the artists followed them.

During the Chou dynasty (c. 1134–247 B.C.) Chinese civilisation reached a high level of achievement: rites, ceremonials, official procedure were established in orderly fashion; the human mind found a sort of social equilibrium for its background; it was a time when the seeds of great thought were germinating. As the dynasty moved towards eclipse, and rival forces rose up to tear the State into separate factions, so human thought underwent a

revolution; in general it showed a reaction against existing circumstances, and a deep regret that the old orderly system of society was departing, apparently for good. Some put all their effort into restoring the old habits of life, the old gradations of society, the old traditions of rulership. 'Let us now praise famous men!' they cried and, gazing through the mists of the past, they found the 'golden' Emperors Yao and Shun worthy figures for emulation. This is the fundamental idea of Confucius and Mencius—of what we call 'Confucianism'. In practice it led to positive conduct; it had some practical rules for living; society was in a bad way, certainly, but it could be saved. On the other side of the scale we find the negative beliefs—if one may so call them—of Lao Tzŭ and Chuang Tzŭ; what we subsequently termed Taoism, after the 'Tao Tê Ching', the Scriptures of Lao Tzŭ. These two philosophers and their followers equally deplored the existing state of fruitless rivalry for power, with all its attendant miseries, but held that a return to a former political state was not enough; the nature of man himself must be changed. They saw the world as a ceaseless battlefield so long as a man was under the bondage of desire; his only salvation would be through a return to his original primitive state, where he learned the art of living from Nature

herself in place of fallible human laws: where he could be 'bounded by a nutshell and think himself king of infinite space', as Hamlet so admirably expressed it. 'Quietism' is one of the key-stones of this school of thought; people, it urged, should maintain the integrity of human nature in the rhythm of life under the Eternal Law, so as to rise above the dust of ordinary affairs. Thus inwardly satisfied, desire for material possession would cease, and with it, conflict. The rulers in their turn would have no need to harass their own people or to look for further conquests among the bordering races. 'No action, no conflict; benevolence and prudent expenditure; in government offer the people kindness and peace'—such is the sum of the ruler's duty. Taoism hoped to save the world by reducing the causes of destruction; Confucianism recognised the inevitability of destruction, of wars and individual conflict, but tried to reduce their sting by binding up society in a system of mutual dependence. The one said, 'There need be no more war if you will listen to me!' the other, 'War may arise but I can subdue it!' These two great systems of thought, with all their repercussions upon personal conduct and endeavour, have really influenced China through the whole length of her subsequent history; they stand side by side, equally balanced; sometimes the one

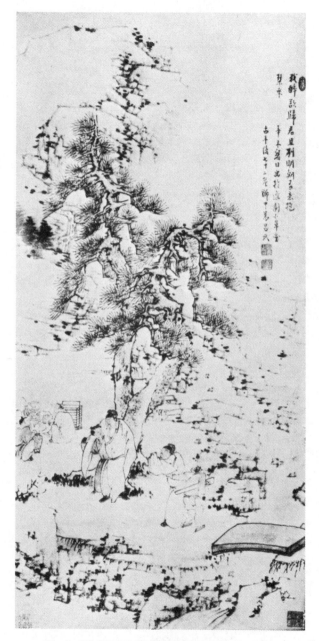

我醉欲眠君且去明朝有意抱
琴來

辛未暑日因撿遺制水平書
古平陽七十二翁中馬昌氏

V A DRUNKARD Yi Ch'ang-Wu (Ming)

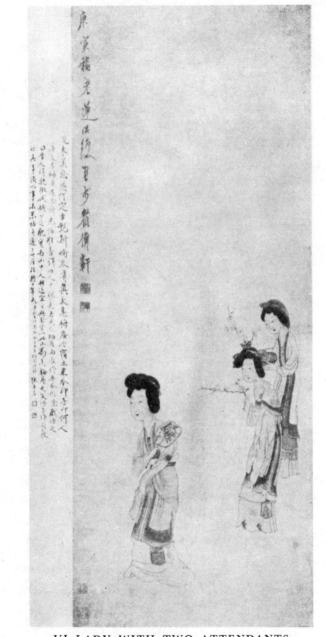

VI LADY WITH TWO ATTENDANTS
'Old Lotus' Ch'ên (Ming)

predominating, sometimes the other. Several different types of thought grew out of them, as developments or in opposition: for example, the altruism and pacifism of Mo Tzŭ, and the egotism of Yang Tzŭ. Subsequently, Buddhism, introduced from India, exerted a powerful sway over people's minds. I should like to give a little space to discussing separately these three main philosophic systems.

The period known as the 'Warring Kingdoms' at the close of Chou, gave our people their first taste of prolonged and desperate fighting, with all the suffering it entailed. China was then divided into a number of feudal states, each with its more or less powerful prince, the more powerful ones often apt to be seized with the ambition to amalgamate all the other states under his own and turn himself into an emperor. For more than a century inter-state fighting continued. Other schools of thought arose to compete with Confucianism and Taoism, and scholar-politicians—detestable combination!—stirred up 'ideological' trouble. Confucianism, however, still predominated, and art appears to have been one of its instruments. To reduce the risk of war and to foster peace and goodness throughout the world, the Confucianists believed there must be a universal standard of good conduct in society.

'First cultivate your personality, then keep your family in order, then set your country in good condition, and then maintain peace in the world.'[1]

The Chou artists made their contribution by forming beautiful ritual vessels; they helped to emphasise the importance of social and religious conventions, so necessary to the somewhat artificial type of society Confucius had in mind. Unfortunately Confucius lays too much stress on the ethical side of human nature.

The Han dynasty (*c.* 206 B.C.–A.D. 219) followed the art designs of Chou; its paintings are largely Confucianist in character, somewhat didactic, with political or educational significance. There are many portraits of noble emperors and righteous ministers to keep the rulers in mind of their duties to the country, and to remind the people themselves of the kind of government to which they were entitled.

The duty of minister to emperor and of emperor to people are the peaks of the system; lower in the scale we find the duties of the ordinary individual to his family and to society at large in the cultivation of his own person. Confucius continually pointed out that each life, however humble, made a contribution to

[1] 'The Great Learning', translated by S. I. Hsiung.

the whole; a small blemish in any part keeps the whole from perfection. Personal integrity, therefore, should be the aim and object of all men; exerted on behalf of others in a limited sphere, it might gradually extend to the whole world. He especially condemned the man who sought for glory and profit, regardless of virtuous living; who was selfish and greedy. Profit he regarded as something defiling man's better nature. We read in the 'Analects' that 'the Master seldom spoke of gain'.[1] And again,

'The cultured man knows the importance of righteousness while the mean man knows the importance of gain.'[2]

Mencius has an even more eloquent phrase on this subject: 'Everything is already complete in myself',[3] meaning that Fame and Gain are already waiting for deserving people, without their seeking; they depend upon character, not desire.

Confucius believed deeply in the potentialities of human character; we are told about him that:

'The Master taught people by means of these four things: Literature, Character, Loyalty and Faith.'

[1] 'Analects', translated by S. I. Hsiung.
[2] Ibid.
[3] 'The Works of Mencius', translated by S. I. Hsiung.

How was the cultivation of lofty character reflected in Chinese painting? Naturally we shall look principally to figure-painting for an answer. The period when this type predominated was roughly from Han to Northern Wei, when Confucian thought particularly prevailed. The first point worthy of remark is the lack of subjects drawn from ordinary human life: most of the figures are poets, philanthropists, heroes, men of high virtue, men of letters, and the like. The portraits do not aim at a 'striking likeness'—apparently the object of European portrait painters; if the painter can but pick out some salient features, preferably those indicative of personality, and add an air of dignity, of noble-mindedness, artist, sitter and philosopher are all satisfied.

Confucianism is a positive philosophy. The depiction of evil deeds, of the mean in human nature, the satirical treatment of life—these are unknown in the history of our art. Your English Hogarth, if he had found himself mysteriously transported to China in the eighteenth century—how do you think he would have been received?

In the most ancient days the forefathers of the Chinese race, like any other race in the world, doubtless made acute observations of the many distinct natural phenomena—rain, snow, wind, how birds fly, and how plants

grow—and could not help expressing their bewilderment, amazement, and awe at the power of nature. However, it seems never to have occurred to the early Chinese to inquire who or what sort of supernatural Being created and regulated the great host of natural phenomena, though they probably believed in some such Being. Therefore, no definite religious system has ever been evolved in China as in other parts of the earth. In peaceful pursuits and in hard work for existence, the early Chinese mind was completely free from any abstract attachment or entanglement. All were living on the same level of bare subsistence in those days and they could learn nothing from one another. Indifference to any kind of worship was prevalent in ancient China. A ballad supposed to date from the days of Emperor Yao, more than four thousand years ago, runs as follows:

> 'Work with the sun-rise,
> Rest with the sun-set,
> Dig the well for my drink,
> Plough the field for my food—
> What do I care for the power above?'

There is also a well-known story about this Emperor Yao; when he grew old and weary of governing, he began to look around him for another who would take his place. First he

visited Hsü Yu, but that gentleman, divining the reason for the visit, escaped before Yao had entered his doorway. Next, he approached a Wise Man, Ch'ao Fu, who, in his distaste for human affairs, had taken to living in the high branches of a tree, in a kind of nest he had made for himself. The Emperor talked long about the glories of the 'Dragon Throne'; 'Why not leave your strange dwelling for the splendours of the Royal Palace?' Yao's words passed by him like the wind; at his departure, Ch'ao Fu washed his ears! This is the type of character we respect particularly in China; Sakyamuni, the incarnate Buddha, though Heir-Apparent to an Indian throne, chose to renounce his kingdom and become a beggar, to experience the sorrows of humanity; for this action especially we deeply admire the life he led.

Although Confucianism laid emphasis upon mutual service its followers could appreciate those who thus remained apart as well as those who laboured for the country—who kept themselves strictly like hermits. Most of our landscape paintings reflect the hermit's outlook; they breathe the spirit of the lonely mountain-dweller. Many people are convinced that this type of person was trained by Taoism, but in Confucius' time the phrase 'Escape-from-the-world' was applied quite freely to those who

preferred a solitary, natural existence. We read in the 'Analects' that:

'The Master said: The worthiest men retire from the world, those a little less so retire from certain places, the next best retire from people of disagreeable appearance, and the least worthy retire from people of plausible words.'[1]

And again,

'Having plain food and vegetables to eat, and only water to drink, and my bended arm to sleep on as my pillow, I can still find my happiness in these things. I consider riches and honours acquired by unrighteousness as void as floating clouds.'[2]

Mencius also laid emphasis upon personal integrity, and the cultivation of individual virtue; he holds up to admiration those whom:

'Riches and honour cannot seduce, power and force cannot bend, poverty and obscurity cannot alter.'[3]

This outlook has sunk deep in our minds through the centuries; men of good character try to keep above and apart from society, studiously to develop their minds, and to express them in paint or poetry. Our artists and literary men are expected to reveal thought and philosophy in their work, and in return

[1] 'Analects', translated by S. I. Hsiung. [2] *Ibid.*
[3] 'The Works of Mencius', translated by S. I. Hsiung.

we respect them as the true aristocracy of China. Confucius said:

'The wise take pleasure in rivers and lakes, the virtuous in mountains.'[1]

Obviously, from his imagery, he had been at times a companion of Nature, but the passionate distrust of society, so long associated with our artists and thinkers, did not develop until a later period, after the whole country had become thoroughly experienced in war. Towards the end of the Han dynasty, there was a succession of bad rulers; civil disorder followed as a natural consequence. Then came the period of the 'Six Dynasties' (c. A.D. 220–588), long years of fighting, unrest, dissatisfaction; there was no real opportunity for reorganising society until the Sui dynasty (c. A.D. 589-617), when China found herself once more under a single ruler. Under political conditions such as these, people of culture despaired about the future; was there ever to be stability on which the human mind might rest? Confucianism had tried to rescue a decaying social order from a practical standpoint, but the outlook of our people at this time was such that the world of affairs did not seem to be worth rescuing; they wanted to escape from it themselves into a more satisfying sphere of existence. Taoism and Buddhism supplied the need. The Taoist looked at the world with

[1] 'Analects', translated by S. I. Hsiung.

cold eyes, cared little for regulating the conduct of life, less for gain, profit, fame, ambition. Life in close harmony with Nature was the only real Life. He was an individualist, not a social being. But though the individualist may be a burden to society, in his refusal to contribute to community life, it is usually the social out-law, the follower of natural promptings, who produces the highest creative work. Confucius admitted that he was himself 'a transmitter, not a creator'. He is said to have collected and edited the classic 'Book of Odes' from tradi-tional folk-ballads, but to the best of our know-ledge he was not a poet. Confucianism by itself could not satisfy; it deliberately avoided specu-lation about a future life, and it provided no imaginative imagery. Taoism, on the other hand, left the mind free to wander in a new ideal world; Buddhism provided artists partic-ularly with a fresh and beautiful range of forms, images, conceptions. Taoism was the first of the two to predominate.

The 'new ideal world' was not far to seek, it existed everywhere in Nature. Lao Tzŭ was not a 'transmitter' but a 'receiver'; he believed that in quiet receptivity, with mountains and streams, clouds and mist for companions, man would be able to feel the workings of the Universal Spirit. Hence the rise of land-scape art in China. Many scholars and men of

culture left the political stage during these days of fighting, and chose to play a less conspicuous rôle in humble, lonely huts among the mountains. Living in continual spiritual contact with Beauty, it became imperative for them to find a form of self-expression; some began to describe the scenes in poems, many others to perpetuate the mountains they loved in paint. Tsung Ping, a landscape-painter and Taoist hermit of the Six Dynasties, in his essay 'Introduction to Landscape Painting' has an illuminating paragraph about this attitude of 'reciprocity' to Nature—if I may use a Confucianist term. He writes:

'I have lost my heart to the mountains of Lu and Heng, and am so constantly thinking of Chin and Wu which I have not seen for such a long time, that I forget old age is approaching me. Regretting that I am unable to enjoy myself—body and soul—by lingering around the water-fall of Stone-Gate, I paint their form and colour from imagination, and create these cloudy mountain-tops.'

Nature is infinitely changeable, and shows herself in different garments to different eyes. Every creation is necessarily tinged by its creator's outlook on life; there is no lack of variety in this main form of our artistic expression, landscape painting. A mountain rock, a few feet of flowing water may stimulate

the onlooker with an almost unlimited variety
of imaginative thoughts, when they are treated
by different artists. A mountain ten thousand
feet high, and a river three thousand miles long
may both be transferred to a square foot of
paper; looking upon them, you will remember
what you saw in Nature and your heart and
mind expand under the vision of her mighti-
ness. One of the reasons for our admiration
of landscape lies in its bond with the philosophy
of Taoism.

After Landscape, we admire and practise
'Bird and Flower' painting, and this fact is
not without its connection with Taoism. Lao
Tzŭ distrusted human knowledge; he admired
the original nature of man before it became
moulded by civilisation; he loved the mind of a
child, and took pleasure in simple objects such
as trees and birds. Living without knowledge,
they also live without desires; they enjoy that
of which they are already in possession, their
natural being. 'Give people', he says in the
'Tao-Tê-Ching', 'blank to look at and sim-
plicity to hold, they will have little selfishness
and few desires.'[1]

Civilisation makes it hard for us to live by
ourselves with the simplicity of a thoughtless
plant, but however sophisticated the Chinese
artist may be in his own contact with society,

[1] 'Tao-Tê-Ching', translated by S. I. Hsiung.

you will find that when he takes up the brush to paint, he will more readily choose an insect perched on a twig, a raven on a moonlit pine, a single lotus plant springing from a pool, than any complicated scene of human relationships; moreover he will approach his subjects in the attitude of the Taoist Sage, putting aside Knowledge, and seeking for that Spirit which is an intrinsic part of all living things from their birth.

In this process, the artist forgets his bodily existence, and this too comes from the training of Lao Tzŭ. The Sage believed that it was not Knowledge alone that led to unprofitable desire, but also our 'substantial' flesh; the great suffering of humans was chiefly to be put down to the body's account; if people could get outside flesh, life could be lived on a spiritual plane, there would be no 'ego', and man could identify himself completely with the life of Great Nature—that Life which Lao Tzŭ calls 'The Way' or 'The Unnamed' or just 'Being'.

'All creatures under Heaven are the offspring of Being, and Being itself is the offspring of Not-Being.'

'We have great anxiety because we have bodies; when we have no bodies, what anxiety could we have?'

'The five colours blind the eye, the five sounds deafen the ear; the five tastes spoil the palate.

Hunting and chasing makes one's mind go mad.'

'The unnamed simplicity will extinguish people's desires. The people's desires being extinguished, there will be peace, and the world will be in order by itself.'[1]

This philosophy of living has had an inestimable influence upon Chinese art; it has enabled those who profess it to identify themselves with all the forms of Nature as they paint; the Chinese artist's flowers do not appear to have been expressly created to adorn his living-room, his trees to shelter him from heat or his animals for companionship. There is no gleam of 'homo sapiens' in the eyes of his horses and dogs, and he may be just as willing to describe a butterfly which has too small an eye to show any evidence of intellect!

'Chuang Tzŭ dreamt that he was a butterfly,
Who dreamt that he was Chuang Tzŭ.
The same body may change its soul;
Everything in this world is eternally incomprehensible.
The water which flows into the deepest sea near the
 Island of Immortals,
Comes from the clear and shallow streams.
The man who planted melons outside the south-eastern
 city gate,
Was, in former days, the Marquis of Tung-Ning.
Riches and honour are just like this,
Why, then, should one toil and toil?'[2]

[1] 'Tao-Tê-Ching', translated by S. I. Hsiung.
[2] Translated by S. I. Hsiung.

So sang our famous T"ang poet, Li Po, inspired
not only by Chuang Tzŭ's dreaming but by
that sage's philosophy. Chuang Tzŭ sub-
stantiated Lao Tzŭ's ideals, and developed them
a little further. Even more than his prede-
cessor, he laid emphasis on natural form; man
should not attempt either to deform or regular-
ise what already existed in Nature. All things
in the world were good in themselves, and every
natural thought right. Neither knowledge nor
rank was of ultimate value; the melon man and
the Marquis, the Sage and the butterfly—Life
manifested itself in them all; the particular
form which enclosed it was a matter for Chance,
not effort. Throw out thought, consciousness,
knowledge, empty your heart, lay it bare to the
promptings of Nature and you will be led to
the pure experience that man ought to have.
The Immortals have no cares; that is because
they are as little conscious of their bodies and
individual lives as the butterflies!

On the other hand, Chuang Tzŭ did not,
like Lao Tzŭ, think that to understand and
enjoy Nature was enough; the enlightened
sage may bring his mind to act upon it without
altering its essence. There is already a hint of
this idea in the 'Tao-Tê-Ching'.

'Therefore the Sage engages in actionless
activity, and practises wordless teaching. All
creatures are instructed by him; he does not

refuse this. He produces but does not possess: he works but does not reap; he accomplishes but does not claim.'[1]

It is not an easy concept to master. Many of our artists go to the feet of Chuang Tzŭ to learn how to proceed in their creative life. They gladly accept his naturalism, the free exercise of their response to natural impressions, but they also exert an 'actionless activity' upon what their eye perceives—bringing far-distant mountains into proximity, or widening the distance between two other ranges. This is no other than an embodiment of the philosophic idea that Time, Space, Distance are relative terms; the mountain remains the same if we transport it from the Antipodes, just like the Marquis and the melon-seller!

But these theories of Taoism were not far removed from the central ideas of Buddhism, especially in its Chinese form—the 'Zen' or 'Meditative' School, as we call it; probably this basic resemblance was the reason why Buddhism found such ready acceptance in our country. During the first four centuries of the Christian era, Confucianism and Taoism predominated, but Buddhism, brought from India not later than the first century, had all this while been adapting itself to Chinese ways of thought; its imagery conforming to Chinese

[1] Translated by S. I. Hsiung.

artistic traditions. Towards the end of the fourth century it had taken firm hold of our imagination. It was a time of particularly acute suffering, and Buddhism, with its sweeping rejection of the world, its promised paradises, and its teaching of bodily forgetfulness, made irresistible appeal to the common people as well as to the cultured classes.

Sakyamuni, the incarnate Buddha, had proclaimed the five sources of human suffering to be birth, death, old age, disease and pain; in his compassion he had wrestled in spirit to find a remedy. Clearly they were all inescapable, but if they could be forgotten, unnoticed . . . ? After some years spent in both experience and meditation, he received enlightenment and began to preach.

'Phenomenon is Emptiness; Emptiness is a kind of Phenomenon.' This is the fundamental principle of his teaching. The whole world is an illusion or a dream—a preliminary to the real Life. It is man's misfortune that he must be born in flesh, and must suffer continual rebirth in various fleshly forms until through personal merit and the Buddha's compassion, he may be transported to the spiritual world. The whole universe is progressing towards this end. 'No action is constant, no phenomenon is real.'

That is to say that phenomenon only exists

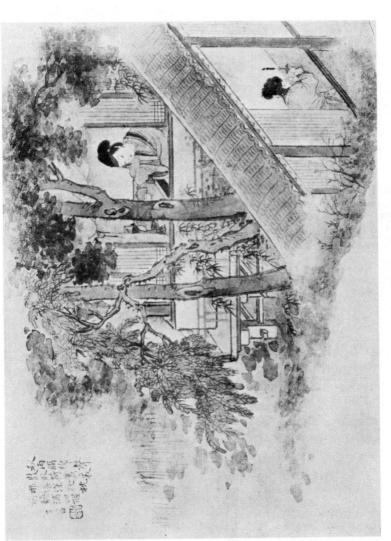

VII RAINY NIGHT Fei Hsiao-Lou (Ch'ing)

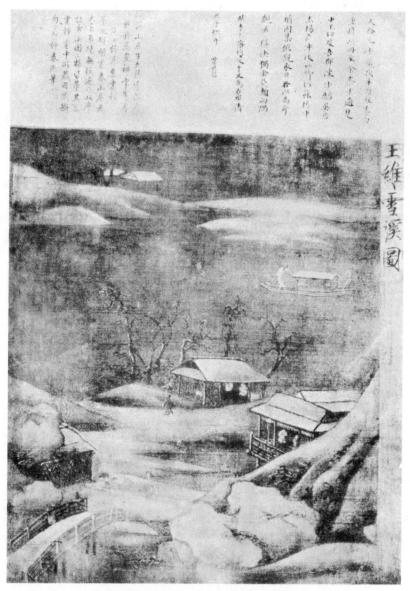

VIII SNOW SCENE Wang Wei (T'ang)

through the imagination of the observer; it is itself Emptiness, an illusion of the mind.

The reputed founder of the Meditative School was an Indian monk, Bodidharma or Ta-Mo; he came on a lonely mission to China. Teaching by example, not by Scripture, for nine years he is said to have sat in contemplation in front of a stone wall without food or rest, so deeply sunk in meditation that the World and the Flesh were both forgotten. One day someone brought him a volume of the Chinese Classics to ask his advice upon their value: he took the book and put it to his nose: 'It has a kind of quarrelsome smell about it,' he answered! Apparently he held the same opinion of human knowledge as the Taoists.

The example of this Darmo and his followers had a very profound influence upon the beliefs of our people; although they did not sit for nine years in thought, many Buddhist believers would retire to the mountains to forget the world, like the Taoists, but they did not pass their days in happy wine-drinking and poetry, but rather in solitary retirement trying to lose the Self. They did not acknowledge the Taoist's Universal Spirit, the 'Unnamed', the 'Being'; the Zen Buddhist said: 'There is no god in the world; if, by constant meditation, you can lose your fleshly

consciousness, you will find the god within yourself.'

In the midst of the sufferings of China, the Buddhists claimed to have found a way to escape: the human heart in its origin, they said, was also empty, but through experience of suffering it grew exceedingly sensitive and apt to pity; without the existence of suffering, this pity which tears the heart would not arise. If one can but imagine that pain and pity alike are parts of a dream, gradually one will perceive that all things have their source in Nothing. If one can forget Self, Pity has no house to dwell in, and without sympathies the travail of the world would not affect one. In this way, safeguarded from the inroads of distress and the fortuitous event, and convinced that the visible Universe is no more substantial than a dream, man may recover his pure original heart, and enter upon that state where the Soul has life. The Soul is by nature good; during life, in its contact with the world it does not corrupt but it becomes covered by varying thicknesses of material degeneration and lost in a 'river of blood'; there is no escape. If, however, man can realise the true nature of the world and of his own soul—that life and death are unimportant, that there is no instrinsic difference between man and man, man and natural objects—all are illusions, then the

Soul's wrappings become fewer; the nearer it approaches its original unencumbered state the less is its owner drawn into the world's wickedness. Without a consciousness of these things a man may easily forget his own nature and throw away his soul. Standing spiritually on a lofty eminence, out of reach of the dusty world, he may attain a truly remarkable nobility of mind.

On the face of it Buddhism appears to be a selfish faith; a man shuts out the world's pain and is intent on his own salvation; but in its final connotation it is not so. Like the Confucianist in practical affairs, the Buddhist begins by 'cultivating his own personality' spiritually, with the intention of eventually embracing the whole universe in his saving arms: first find enlightenment by losing the world, then carry the lamp out into the surrounding darkness!

Such are the main features of our three great Philosophical Ideas. Each of them aims in different degrees at bringing people back to an original state of goodness. Like Janus, our Idea is a two-headed Being with backward and forward gazing eyes! Because our people have for countless generations been trained to search for their original good nature, part of their gift from birth, you will find that they are ready to tolerate without retaliation. A broad

and noble mind is the fruit of all three, and it is the artist's expression of personal nobility that we especially look for in a painting.

Zen Buddhism and Taoism have many points of similarity, but chiefly the aim of leaving the practical world for a life apart, where the spirit may prosper. In leaving the crowded highways, painters who accepted these faiths gave up figure-painting in preference for land-scapes, and public taste supported them. In the creation or contemplation of landscape art the human soul has space to grow in. The earliest ideal was to express this high manifestation of the living soul, and so it came about that Hsieh Hê's 'Rhythmic Vitality' (p. 33) became the touchstone of a work of art: a painting must pierce the superficial covering of material Form, and make clear the rich inner life of the object in harmony with the artist's own soul—only then can it be termed a masterpiece.

It is the natural instinct of humanity during a period of social disruption to look for escape into a different world; and painting and literature will follow the general trend. 'Landscape' and 'Flower and Bird' painting, established in the troublesome days that preceded T'ang, during that dynasty and those that followed grew increasingly in strength and beauty. A single mountain or stream, a single blossom can give

one the impression of living *in* Nature; in-
expressible but palpable. From a small paint-
ing of a rainy or windy scene, given an artist-
philosopher, we may feel the dynamic nature
of the universe. Since Taoism teaches that a
free soul is not constrained by logic or ethics
or man-made laws, but lives in simplicity and
harmony and sees life as a whole, figure-
painting and the depiction of everyday human
affairs has no interest for our artists.

Your poet Wordsworth approached Nature in
a spirit very similar to that of our own poets
and artists; somewhere he has written:

> '. . . 'Tis my faith that every flower
> Enjoys the air it breathes!'[1]

We too are convinced that natural things do
indeed possess and enjoy Nature; following our
philosophical thought, we earnestly desire to
live with them the life of Nature. We have
the same reverence for flowers and birds, for
all natural life, as one has for children because
of their simplicity and innocence; we love to
paint these in preference to man. Even insects
and fish can be good subjects for our brushes;
nothing which is natural is too humble or too
unpoetic. Whatever we choose, we try to paint
it in its original state, free from the touch of

[1] 'Lines written in early spring'.

civilisation; this, I think, must be a rare ideal among painters of the West.

Confucianism provided a sound ethical system, but it left little scope for imagination, and supplied few drops of spiritual comfort. Taoism and Buddhism brought the people to a fresh, new, strange place; they made the hermit's life attractive even to those who enter it as nature-lovers, not religious recluses. We admire this kind of life; to our eyes it is the best doorway to the Creative Life, neither ridiculous nor wasteful; we must thank our Sages that through them we have been able to keep a simplicity of mind.

PAINTING AND LITERATURE

ALL over the world, the varying forms of Art have elements in common; the very terminology indicates their meeting-places: the English speak, for instance, of a painting's having 'Rhythm', the element of music, of a musical composition's having 'Colour', of a poem that has 'Melody', that 'depicts' such-and-such a scene, that is 'pictorial'. Nor would one deny that all the Arts are prompted by the same still Spirit, and move towards the same goal—the apprehension of eternal Truths and the embodying of them in forms acceptable to the human mind. There are, however, instances where not only base and goal but also means are shared: Chinese painting and literature provide one of these instances.

In my second chapter I spoke of the painter Wang Wei of the T'ang dynasty inaugurating a new type of landscape art, founding thereby what we have termed 'the Southern School' (p. 39). It was at this point that literature and art united in China, and if the Western onlooker is to understand the work of this 'Southern' or 'Literary' School, it is in the

mood of the dreaming poet that he must make the approach; he must 'read' and 'feel' them.

From earliest times, Chinese art and literature showed this tendency; as I mentioned in the 'Historical Sketch' (p. 16), our primitive handwriting was a kind of rough painting, used as a means of expressing thought; written character has never yet been divorced from art; in proportion as it became a representative symbol in place of a primitive and recognisable picture, so the art of writing the symbols itself grew more refined; nowadays, a piece of good calligraphy is ranked as high as a work of art and is as expressive 'pictorially' as a picture: the placing of the characters, the Touch of the artist, the Life of the strokes, Balance, Rhythm, Design— all these are of first importance to Chinese calligraphy.

On the other hand, our painters do not hold beauty of Form and Colour as their sole object; they lay particular emphasis on an underlying idea, what one may call the 'literary content'. Chinese landscapes appear to the casual observer as so many repetitions of natural scenes; many grow tired of our perpetual mountain peaks and waterfalls, executed now in one type of brush work, now another. But to our eyes they contain an almost unlimited degree of

inner significance, just as Shakespeare's lines
from his sonnet:

> 'In me thou see'st the twilight of such day
> As after sunset fadeth in the West . . .'

call up feelings and visions as varied as the
minds of the readers themselves.

The tendency for literature and painting to
unite, first evident in primitive picture-writing,
and brought into special prominence in the
T'ang dynasty by the founding of the 'Literary
School of Landscape', during the Sung dynasty
became paramount. The Emperor Hui Tsung,
as I mentioned in the second chapter (p. 44),
particularly anxious to encourage painting,
made the painting of a picture with literary
significance, part of the qualification for official
rank. He would choose a few lines from a
famous poem, and require them to be rendered
in paint; subtlety of thought rather than artistic
execution won the highest praise. For in-
stance: on one occasion he chose the very
simple line,

> 'A monastery buried deep in the mountains.'

The winning painting showed something re-
markable: the scroll was densely covered with
mountains; in the foreground was the small
figure of a monk coming to fetch water from
a stream; no sign of a building . . . But the

artist had indicated clearly enough that there must have been a monastery hidden in a mountain valley or among the trees, or why should there be a monk collecting water?

Another time the Emperor picked the line,

'When I return from trampling on flowers, the hoofs of my horse are fragrant.'[1]

There were no flowery meadows in the winning picture; we Chinese prefer the inexplicit, the merely inferred. The horse appears to be walking along the pathway with a pair of butterflies fluttering round its hoofs; obviously it must have been treading on flowers or these perfume-lovers would not have been attracted to its hoofs!

There is a third example which is particularly interesting: the Emperor chose the line,

'One speck of red among ten thousand of green.'[1]

One of the candidates painted a stork in a group of pine trees, a speck of red on its head being the only touch of red in a mass of greenery; a second, the famous Liu Sung-Nien, showed the crimson sun setting over a welter of green waves, but the winning scene was that of a girl leaning pensively on a balcony with a

[1] Translated by Innes Jackson.

cluster of willow trees below. The word 'red' in Chinese symbolises a lady, because of her rosy cheeks and lips! These games of mental ingenuity are very much beloved in our country.

We have terms to describe this relationship; we call poetry 'the Host' and painting 'the Guest'; poetry invites painting to display her skill and beauty. Only if the poetic idea was well expressed could a painting win the highest praise. And so we reach the first hypothesis, that the Chinese painter must also be a student of literature. In practice, he is very often a poet as well.

I tried in my last chapter to make clear to you how deeply philosophy has influenced our national thought; I showed how Chinese philosophy turned the people's minds to Nature, rather than worldly affairs. Painting in its strong bias towards landscape exemplifies what we call the 'Soaring above the world and enjoying Nature' principle, and poetry accompanies her into the same philosophy like a twin sister. At the time when figure-painting, especially political portraiture, was practised to the exclusion of landscape, poems of the same period described human life, with more than a hint of political significance. But gradually, as landscape rose to the place of honour in the T'ang and Sung periods, poetry also chose

natural scenes, with some personal or general significance beyond the simple description, as their main subject. The setting sun, the weeping willow might betoken parting and grief in the same way as a painting; or the description of a range of towering mountains might connote the poet's loss of identity in the universal spirit of Nature, just as clearly as an impressive painting. Su Tung-P'o had an idea of this sort in his short poem 'Written in Hsi-Lin temple', a poem of philosophy and suggestion which defies adequate rendering:

'Ridge after ridge and peak after peak there are;
From afar or near-by, from above or below, each has
 a different form.
The true features of Lu Mountains cannot be recog-
 nised,
Because we ourselves are always engulfed in these
 mountains.'[1]

It seems to me that a painter, receiving from Lu mountains the same invitation as Su to share in the life of Nature, would achieve with his brush and ink an almost identical effect in relation to the imagination of the reader or onlooker. We call our poetry the picture of a natural scene, using characters for colour and form. The technique of the two kinds of art may differ, but before the painter puts his brush into the ink, and the poet writes down his

[1] Translated by S. I. Hsiung.

lines, there may be no difference in their thought. I doubt if this holds true of any country in the West; Truth and Beauty are the stimulants and goals of Art, but your poets and painters are moved by very different manifestations of them, and embody them from different aspects; they have not subjected themselves as completely as we have to traditional lines of thought; rather they tend to pride themselves on being iconoclasts![1]

Our poets and painters seemed to have observed Nature, not only with the same feeling but with the same eyesight; there is something remarkable in the part played by perspective, for example, in the poet's workshop, although it is properly the tool of his brother. The painter may finger all parts of the universe as if they were his toys; far things may be brought near, the large made small, the square not square, high and low reversed. Prosaically we say it is 'Perspective', but our poets realise it may well be a kind of magic, like the yeast in a helpless lump of dough. Without the painter's observing eye we cannot grasp the meaning of many a line in our poetry, but without the

[1] The Chinese poet Tu Fu, of the T'ang dynasty, has two illuminating lines which I may quote in this connection. He writes:

'Tranquilly regarding all things means self-realisation. My absorption in the changing scene is the same as all men's.'

poet's insight into the uses of language—allusion, suggestion, enchantment of sound—we shall not be aware of the transformation from law to poetic un-reason. Here is an example from the poet T'sên Shên:

'Gazing from this wild field, men are like dwarfs;
A bird seems level with the tip of the firmament.'[1]

Apparently the poet was lying idly in the thick meadow-grasses; far in the distance he could see some figures moving about, and immediately above his head a bird flying. The painter knows he must reduce the size of people who are far off, and that if an object is just above the eye, space beyond it will not be visible, but it takes a poet to impress one with the imaginative idea that the bird has flown out of a scientific world and can exist in the refined air of the very utmost limit of space. Again he writes:

'The cliffs of Ch'in are not so high as my balcony;
Wei river is as small as my window-pane!'[1]

Now, Ch'in cliff and Wei river lay in the far distance; T'sên had overlooked the miles between them and himself, as he sat watching them from his study window, just as a painter brings a distant scene into the dimensions of his picture, but the poet's version of the ways of human eyesight carries us to the borders of Lilliput!

[1] Translated by Innes Jackson.

The painter juggles with heights as well as distances, he makes the high low and the low high; poetry transforms this natural process of draughtsmanship into language as sweetly fantastic as a pleasant dream. For instance, the T'ang poet, Mêng Hao-Jan, once wrote:

'The wild waste of sky falls lower than the tree-tops;
On the clear river the moon creeps up to me.'

From a distance the sky appears to curve down below the trees, although in reality it is always leagues above them, and who has not known the companionship of the moon when its reflection lies on the surface of calm water?

Now see the reverse process; in a poem of Li Po we read these two lines:

'The waters of the Yellow River come down from Heaven . . .'

'I see only the mighty Yangtze flowing into the sky!'[1]

Li Po was imagining himself by the lower reaches of the Yellow River, and looking upwards; in the distance the upper river rushing and foaming over high rocks might well seem like a waterfall tumbling out of heaven, and in the far-away the Yangtze might appear to flow into the sky, but it needed the vision of a great poet to make so simple a fact into a thing for wonderment. Su Tung-P'o carried the painter's

[1] Translated by Innes Jackson.

vision to an imaginative degree beyond the power of paint; he writes:

'Reaching up to Heaven the Lotus leaves melt into an infinity of green.'[1]

The artist can only depict that which is within the limits of human eyesight; it is left to the suggestive elasticity of words to bring man within sight of infinity.

Clearly then, the poet's and painter's observation of Nature is true in a different sense from the truth of logical experience, and the difference arises from their desire to bring all things into a single plane of observation, neglecting distance. It is like the English rhyme that you teach your children:

'How many miles to Babylon?
Three score and ten.
Can I get there by candle-light?
Yes, and back again!'

But a law that the painter takes for granted, the poet often transforms into a fantasy.

There is one fact we should notice here: we find that Chinese artists prefer to paint vast expanses; very seldom do we meet interiors or scenes close to the observer's eye. The usual explanation is that 'Power' is one of the qualities chiefly admired by us, and that the great strength of Nature can best be represented

[1] Translated by Innes Jackson.

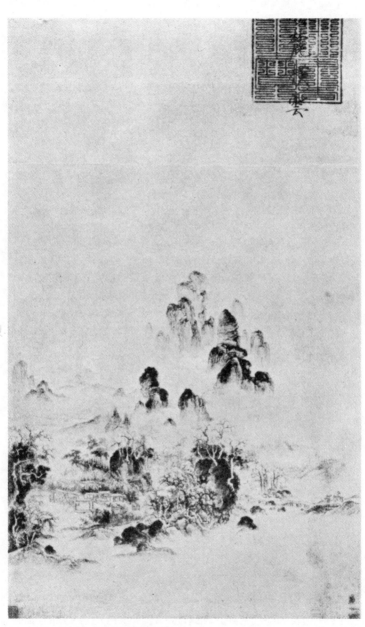

IX A CLOUD-CAPPED HILL ON A FINE MORNING
The Emperor Hui Tsung (Sung)

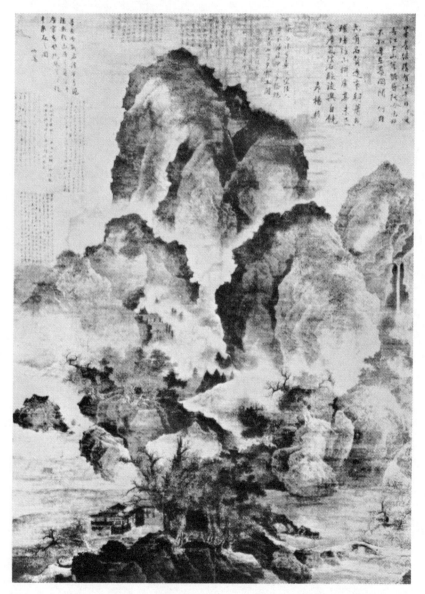

X SITTING IN CONTEMPLATION BY A STREAM Fan K'uan (Sung)

by far stretches of water and huge mountain ranges, but it may also be true that the artist loves to feel his own controlling hand touching the contents of the universe—the grown boy playing at Creator. We have a hint of this in Ku K'ai-Chih's essay 'On the Painting of Cloudy-Terrace Mountain' where he writes:

'The painter can put a glorious cloud in the West and compel the onlooker to believe that it has risen from the clear atmosphere of the East.'

Here he represents the artist as exercising a power not second even to Nature's. Similarly we shall find that poets, too, often prefer the expansive and far-reaching, although it is more within the capacity of their medium to extract the human significance from more homely scenes. But if the central theme of a poem concerns the pool of a temple courtyard, we may be sure to find the long mountain pathway that leads to it; or if the poet describes a small hut where he parted from his friend, he will not fail to allude to some detail of his homeward journey. It is possible that like the painter he enjoys making these imaginative, fantastic statements based upon heights and distances. Wang Wei, the poet-painter, is one of those who well understood the manipulation of dimensions; I cannot leave this branch of my subject without a single quotation from his

poems: here is a line struck off in a sudden flash of insight:

'One night's rain in the hills,—a hundred fountains in the tree-tops.'

Evidently he had seen distant mountain streams swollen with rains, rushing down into a wooded valley. What a combination of artistic vision and poetic concept![1]

Our poets and painters alike try to convey a sharp, vivid impression of Nature; we use the word 'engraving' for this, in preference to your 'impression'; the significance is obvious. The painters of the 'Literary' school do not study a landscape tree by tree and stone by stone, and fill in every detail as it appears to them, with brush and ink; certainly they may have been familiar with the scene for months and years, without seeing anything in it to perpetuate: suddenly they may glance at the same waters and rocks in a moment when the spirit

[1] As an example of the same qualities brought into the service of a near-by scene, I may quote the lines of Kung Hsiang-Lin:

'There is an elegant lady on the tree-top,
A Spring breeze blows on the painted balustrade . . .'

One must imagine a pavilion with a small painted balcony; on the balcony a little lady quietly leaning; beneath, the trees reach up to her chin, hiding anything so material as railings! Now she seems to be hanging on the trees; a truly perilous position, and such a slender lady too . . .!

is awake, and become conscious of having
looked at naked 'Reality', free from the Shadow
of Life. In that moment they will take up the
brush and paint the 'bones' as it were, of this
Real Form; small details are unnecessary.
Space is left around the 'bones' for the spec-
tator to add his own flesh and clothing;
they are merely adjuncts. You will find the
same process at work in the creation of our
poems; they are mostly very short in compari-
son with Western practice; four vivid lines or
eight, each character vital to the whole effect,
and this effect not a detailed description, but a
sudden living impression flashed into the recep-
tive poetic mind. Increasingly one is aware
that there is no sharp division between Nature-
poems and Nature-paintings in China.

Our poets in depicting Nature have no lines
or colours to help them, but only their own
sharp eyes and skilful expression; in their effort
to seize the essence of some form and briefly,
sharply, to convey it to their readers, they may
tend to 'exaggerate', rather like your Lyric
writers of the Elizabethan age. For instance
our poet may refer to a lady's eyebrow as
'Willow brow', from its slender curved outline
like a willow leaf; or her lips he may call
'Cherry-lips', from their redness and sweet
full shape. Our painter in his turn will bring
these qualities to life, although they are not

'true' according to the common laws of reality. In our figure-paintings, the lady's brows are indeed like willow leaves and her mouth like a fresh cherry. They both seem to observe matter not only with the same sensitive eyes, but with the same mental reaction; their 'impressions' are similar.

In figure-painting and in poems descriptive of human life we do not aim at verisimilitude, but at extracting both the formal and the imaginative essence. In actual life we call ladies by the names of flowers—'Plum-flower', 'Orchid', 'Apricot-blossom', 'Perfume', 'Bud', 'Chrysanthemum', and so on; and in poetry we allude to them delicately as if they were the flowers themselves. The Chinese love of symbolism may provide another reason for the narrow scope of Figure-painting; we prefer to paint the flower than to express the human form of which it is the symbol. In this way our poet need never speak outright about the maiden of his heart, as you so often do in the West; he may write his love letters in discreet poetic allegory. He will use white jade to depict the cool freshness of a lady's appearance, or the moon the calm of her face; the flight of swans stands for her graceful gestures, or the movement of Autumn clouds; her eyes are symbolised by water to show their brightness and limpidity, and her eyebrows, if they are not

'willow leaves' are 'Spring mountain', by which is betokened the faint outline of a mountain range seen through the spring morning mist.

Just as with form, so with colour our poets and painters pick out the basic impression only. You will have noticed that we apply our colours flat without gradations for shadow, drapery and perspective. If we notice that the most important characteristics of a willow tree are its gracefully drooping branches and delicate pale green colour, we shall be content if we can capture the rhythm of its swaying limbs and the essence of the green colour which our eye loved; we do not trouble to darken the under-branches or even to throw its shadow upon the ground below.

The poet's practice is very similar; in the short lines of his short poem he uses a kind of generalised colour-palette. You will remember the 'one speck of red in ten thousand of green' (p. 90); not only is a lady's complexion simply referred to as 'red', but her forehead is 'yellow' and her temples 'green', by association with the colours of an ancient traditional head-dress. The same simplifying process is noticeable in his descriptions of trees, fruit, flowers, scenery; the orange fruit and young willow leaves are alike termed 'golden' from their association with the sun. Pavilions are

traditionally 'red' from their most frequent colouring, although they may be decorated in all possible shades. Similarly, distant water is 'white water' in poems; when one gazes directly down into it, it is 'green', or water that carries sand or silt like a swift river is 'yellow'. If a poet writes of 'red leaves' we know that it is autumn, and of 'green' that it is summer, although autumn is rich in yellows and browns, orange and russet, and spring has also greens among her pale-coloured blossoms. Both poet and artist are aware that it is the predominating colour that impresses inwardly, and even influences surrounding hues; such is the process of the human vision working in union with the mind; it is only if one stops to analyse scientifically that the exact and logical relations of shapes and colours become evident; the Chinese Man of Art never waits upon Logic! When a great poet like Po Chü-Yi says:

'The colour of the moonlight is like water,
The water like the hue of the sky'[1]

at once we apprehend his meaning—we do not pause to reason. Poetry and painting thus seem to have a kind of counter-action upon each other; in writing poems we use the artist's observation; in painting a landscape

[1] Translated by Innes Jackson.

we translate the poet's terms into colour and shape and fall in with his mood.

In Chinese paintings you may be troubled, not only by illogical colours and forms, but also by unnatural disposition of objects; in this case too the artist has looked at his subject with a poet's eye. Just as the eyebrow of a lady is supposed to be like a willow leaf, her face like a petal of a lotus flower and her hair like a cloud, so the artist will describe his figures with a fine disregard for anatomy, and his buildings careless of the laws of architecture. There are some common expressions in our poetry like 'The Nine Curves of the Yellow River', and 'Ten Thousand Miles of the Yangtze', which are the poet's way of expressing great length and great undulation. When Su Tung-P'o writes:

'Through thirty miles of apricot blossom on both sides
 of the road
The new nobleman's horse gallops as if with wings'[1]

it does not mean that he has measured the distance with a yardstick, but that his mind has been 'engraved' with a vision of horse, rider, and a wide stretch of apricot trees in bloom. Chinese poetry is an inexplicable mixture of the apparently concrete and definite with the thoroughly elusive and intangible.

Chinese painting may receive the same comment; occasionally we paint vague and misty

[1] Translated by Innes Jackson.

scenes, but it is much more usual to brush with firm stroke and clearly defined boundary. But if we examine carefully we find that the decisive touch has not precluded imagination. Someone will paint a flower with no root, another will add the roof of a Pagoda to a mountain so distant that ordinary human eyesight could never have discovered a habitation there. Or among some wild hills an artist will put prowling wolves as broad as the crags and as high as the tops of the pine-trees, while many a fellow-painter will abruptly cut short the movements of his brush, enveloping the rest of the scene in cloud, or letting it sink into blankness—a speaking space more eloquent than form! Judged by facts, we know they are all mistaken, but we are not troubled so long as we can feel the imaginable life of the forms themselves, and of their creator.

The painter's aim is to convey an atmosphere, a poetic truth; because they are so often poets, their thought cannot escape poetic expression. Whether we paint a small orchid, a young tit or the rugged cliffs of the Yangtze gorges, we must always have some poetic message to convey. If only we can transfer to the mind of the onlooker this fruit of our meditations, we do not care about verisimilitude; Reason and Unreason can tip the scale as they choose. Though the object we represent may not resemble the

real thing, we dare not deny it life if it has the deeper life flowing from the artist's mind down to the brush's tip and mingling with the ink as if it were his own life-blood.

I have spoken of the sensitive approach to Nature, in which poet and painter seem to share experiences, and of their equal employment of that process which you may now understand from the clue-word 'engraving'. There is a third possible attitude towards living things, and it is perhaps the most important mental process in Art: it is that movement of the sympathies where the onlooker loses his own identity and becomes one with the 'observed' and eventually with the Great Spirit of the Universe, which informs everything that has life. Our poets can talk with Nature; our artists act with her. Hsieh Hê said that to capture the 'Rhythmic Vitality' of any object was the painter's chief pre-occupation, implying that all things in the Universe were possessed of life (p. 84). We believe that not only man but animals, flowers, and grasses, the living rock of mountains even, are possessed of some degree of intelligence, and that there can be mutual understanding between them and him if he will lay himself open to their form of language. A stalk of grass or a small stick can feel the rhythm of life, and the artist of receptive mind can with his ready brush free

the spirit imprisoned in form, as Prospero en-
franchised Ariel, the spirit of air and music,
from the hollow oak, in Shakespeare's play.

The poet has more power than the artist to
give explicit voice to this universal intelligence:
the one can only paint a bird appearing to ask
a question, for example, or with its small throat
puffed with pride in its singing, or seeming to
rejoice at the opening of flowers in spring.
But in a poem we can hear the question or the
joy. Here is a means of associating the reader's
feeling with the life of Nature. The poet Huang-
Fu Tang writes to his lady:

'The flowers at your upper window laugh
at your sleeping alone' as if the blossoms could
well understand that they two should be
dreaming side by side.

Perhaps because they seem to have faces we
very often write of flowers as if they were
human; Ou-Yang Hsiu, for example, has a
poem about a sad lady swinging to and fro in
a tree of rosy blossom:

'With tearful eyes she questions the flowers who offer no
answer;
In tumbled crimson crowds they fly, rushing past the
swing.'[1]

Because we feel this close sympathy with
flowers, we use them not merely to represent a
human quality, as in the names of ladies, but

[1] Translated by Innes Jackson.

also as symbols of a mental state: the flower beaten down by rain betokens a man crushed by disappointment; with its face turned towards the sun it represents a man become suddenly rich, while a young green tree always stands for a youngster.

The song of birds is a pleasant sound to our ears, and we like to interpret it as human speech, praising, blaming, comforting. For instance, a Yüan dynasty poet writes:

'The precious pond is full of water, on which the love-
 birds sleep,
The wind has blown open the embroidered curtain of
 the door and the parrot has learned the secret.'[1]

Or we may turn to Huang Shan-ku's poem:

'Who can trace the whereabouts of Spring, who has no
 foot-step
Unless we question the golden Oriole. . . ?'[2]

The moon rising at night is beautiful in form and mood; we love to paint her in our landscapes and to make her the companion of our poetry. Li Po's lyric to himself, his shadow, and the moon, is justly famous; in jovial mood he cries:

'I lift my wine-cup to invite the bright moon,
With my shadow beside me, we have a party of three.'

[1] 'The Western Chamber', translated by S. I. Hsiung.
[2] Translated by Innes Jackson.

And Su Tung-P'o has almost identical lines:

'Whom do I sit with?
'Tis the bright moon, the clear wind, and my own
 shadow.'

Su was evidently a little less fond of the wine-cup!

Although the artist has no means of expressing his identification with natural things like the poet, we can feel well enough from his work whether this process has indeed taken place; if we as onlookers empty our minds of preconceptions and open them freely to the artist's persuasion, we may ourselves feel the life of Nature flowing from the painted scroll. To the Chinese mind this is the test of true art. All roads lead to the same goal at last—the Rhythm of Life; if the structure, composition, brush-work are all perfect, but the Rhythm unfelt, the picture degenerates into vulgarity. How do we attain the Goal? Not by practising for years in studios. How else but by thought and intensity of feeling, the attributes of the Poet?

INSCRIPTIONS

By 'inscriptions' I mean the piece of poetry or prose woven into the design of a Chinese painting; we can hardly say it is 'written on it' for it is a part as vital to the whole as the boat to the lonely fisherman. It is, however, a factor quite strange to Western art, and needs a little explanation.

Inscriptions may be divided into two classes: those written by the artist himself and those by others, be they friends of the painter, collectors, or connoisseurs. Position varies according to the demands of each work of art; sometimes the painting surface presents an ineloquent, blank space; the Westerner might perhaps add some massed clouds or a forested skyline, but in China we do not like to put any forms which are not indispensable to the painter's message, and so we would compose a poem in the same mood and write it there—a poem which would be a version in language of our brush's story. The style of the calligraphy would be in *perfect* harmony with both style and content of the painted impression. If painting and inscription are by the same hand you will often notice an inner harmony of stroke; a

powerful, rugged tree study may be accompanied by an almost dogmatic type of handwriting, while a delicate, wind-swept willow on a hill-slope may be described in a fine and elegant calligraphy. It is a harmony not of line, but of mood. This type is most interesting to the real student of art as it shows two aspects of brush-work harboured under the one idea; it gives significant lessons in composition.

Another function of inscriptions is to shed added light on the artist's purpose or basic idea; it helps to remove obstacles between his creative mind and the understanding of the onlooker. In such a case, since it does not necessarily form part of the artistic design, it is sometimes written separately on the mount. The silks and papers, on which we paint, are, as you know, mounted upon long scrolls of thicker paper or brocade; sometimes narrow blank sheets are pasted above or at the sides for inscriptions. Occasionally there are writings both inside and outside the painting proper.

Besides providing a commentary, the inscription may contain criticism or approbation from other painters (prominent political men, or even the Emperor himself); you will find our paintings often provide interesting social documents in this way.

Finally, the inscription may commemorate. Painting and poetry with us are as natural a part of our poets' and painters' lives as their sleeping and waking, wine and food; they record not only the occasion of some inspired vision, but the commonplace visit of a group of friends to pass away a moonlit night in conviviality. On such a night one would take up his brush to express the scene in a stanza of poetry; another, between the replenishing of wine-cups, would paint an impression of the landscape in some rapid, joyful strokes, while a third, his imagination straying into far distances, might draw upon his scroll the Peaches of Eternal Life, as a symbol of his desire that such a life together should endure for ever. The memory of that night would doubtless be perpetuated by inscriptions recorded on the paintings.

Such is the general character of our inscriptions and their usage: I must now give an outline of their historical development.

In the early history of Chinese painting, when it was still the servant of religion or government, artists were accustomed to conceal their identity; they were not protagonists in the fight to free Spirit from material form, riding under their own banners, but indistinguishable parts of the State machine, helping to encourage the people towards a condition of

healthy Order. This held true of Chinese artists as it did of the European ones of the Middle Ages. Before the Chin dynasty no painter wrote anything upon his work, even a signature; indeed, the tradition was maintained as a general rule until the early T'ang period. The T'ang painters were individualists, and art, for the first time, became thoroughly self-realised. Then they began to add a signature, but with a great show of modesty: they would write it in very small characters and hide it in a dark place—a tree-root or a hole in a rock, or among the grasses—not to let it obtrude upon the design. If they were not first-class calligraphists they would even sign their name upon the back of the scroll.

In the Sung dynasty artists grew bolder, and would inscribe inconspicuously their name and the date at the base of a painting, on the extreme edge. Su Tung-P'o, the poet, painter, essayist, and humorist of that period, in the strength of his inventive genius, laid the precedent for later practice of inscription writers. His talents were so well balanced between painting, poetry, and calligraphy that he could combine all three in the same work. These paintings, enhanced by poems and inscriptions in perfect calligraphy, are of three elements but one flavour. As far as we can judge of his character, he was a man who cared neither for

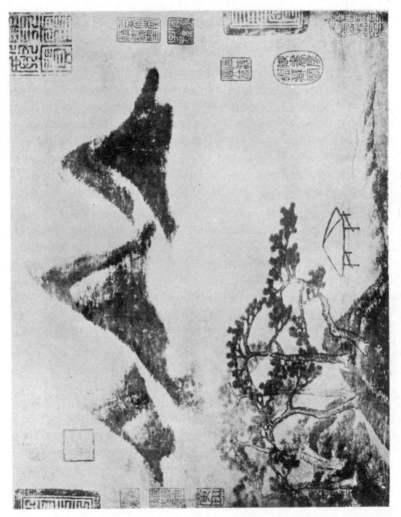

XI PINE AND BOWER Mi Fei (Sung)

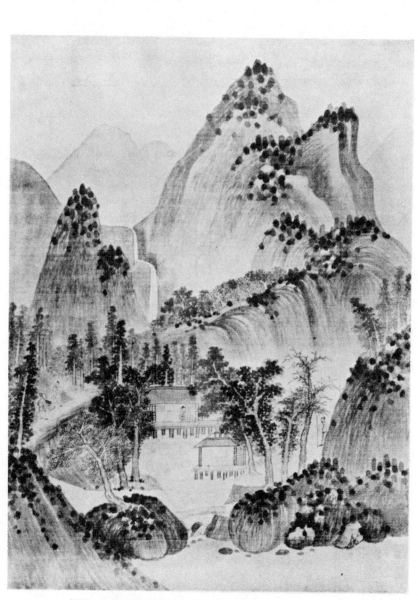

XII A SECLUDED VILLA Tung Pei-Yüan (Sung)

the regulations of society nor for artistic convention; he seems to have had spasmodic bursts of inspiration, and at those times he would forget everything but the dæmon with which he was momentarily possessed. We can see that in his paintings of bamboo branches he neglected the conventional arrangement; there are empty spaces where no spaces should be according to the old ideas, but these he swept over with brush-work of another kind—a gracious poem or a sweetly turned phrase of his own invention. Mi Fei, a contemporary landscape artist, had a similar practice, decorating his scenes with descriptive poetry. Between them they set a fashion which developed eventually into a lasting element of Chinese art. It is only one of the ways in which Sung painting moved towards the field of literature; the tendency is, I believe, unparalleled in European art, and may be a serious barrier to mutual appreciation.

In two previous chapters I have discussed the relation between painting and philosophy, painting and literature; inscriptions are an adjunct to both these relationships. Before an artist puts brush to paper he must be inwardly moved by pure inspiration; out of this intangible, unconjurable Something, in its contact with the artist's being, is begotten a feeling in which the god and the artist alone participate.

By careful fostering the Feeling grows into
Thought, and at this point the new creation
is ready to venture into the world: the artist
mixes his ink and gets to work. Each painting
is the record of an individual thought, more or
less expressive; should it be self-evident, the
artist need not make any additional comment,
but since Man's hand is fallible, and brush and
ink but material implements, it often happens
that the onlooker has no more than a hint of
the artist's original meaning from the painting
itself. And so an inscription is added for
enlightenment, as with Mr. Su's bamboos.

'Now, these bamboos need not contain any
deep philosophical idea,' you may contend,
'and we can all see from what plant they spring,
and that they are tossed by wind, or lying
calmly on the air.' To this comment I should
reply that you have not completely realised the
outlook of the Chinese artist. Verisimilitude is
never a first object; it is not the bamboo in the
wind that we are representing but all the
thought and emotion in the painter's mind at a
given instant when he looked upon a bamboo
spray and suddenly identified his life with it
for a moment. That moment may have had a
psychological significance in itself—the artist
was leaving his native city, or parting from
friends; then the drooping attitude of the
leaves will have a meaning for their creator

beyond the comprehension of the onlooker had he written no explanation.

Our traditional thought is deeply imbued with philosophy, Taoist and Buddhist; painting cannot escape. We do not always bring Nature into harmony with our own emotions, picturing a weeping willow to reflect a personal grief; we try, in the steps of the Sages, to lose ourselves in Great Nature, to identify ourselves with her. And so in landscapes, in the paintings of flowers and birds, we try not to imitate the form, but to extract the essential feeling of the living object, having first become engulfed in the general Life Stream. This process is an aspect of the artistic consciousness which is very hard to express, but the inscription may help, at least, to bring out the relationship between profound philosophy and art. We should learn not merely to love and understand the painting itself, but to look for a meaning far beyond its confines in a world of the Spirit.

We have never elevated figure-painting as you have in the West; some of it may have a religious significance, but it seldom reaches the depths of thought which landscape attains. Moreover, pure figure-painting of human life is presented with almost 'Puritan' reticence. If one consults Ku K'ai-Chih's masterpiece, of which there is an early copy in the British

Museum,[1] one will realise the Chinese attitude well enough.

It is a long roll in illustration of a text by Chang Hua, a poet of the third century A.D., entitled: 'Admonitions of the Imperial Preceptress to the Ladies of the Palace.' It represents various scenes of domestic life—a lady having her hair dressed, a bedroom conversation, an Imperial family group, and so on. Each scene is a miracle of eloquent life and, according to Western outlook, no more would need to be added. But to our taste, though art need not be didactic, it should never be frivolous. On each group of figures some inscription has been imposed; beside the lady in converse from her bed-chamber we read:

'Good utterance will be assented from those a thousand miles away, while words of contrary nature will create suspicion from even your bed-mate,'

while the family group bears the lengthy warning:

'A word, though unimportant, will result either in honour or shame.
Don't think that it is dim and therefore matters not,
The divine eye penetrates into things invisible.

[1] This painting has been the subject of much discussion, and various opinions have been passed on period and sources. I myself dare not assert that it is a genuine work of Ku's, even if we admit that the obviously false signature may have been added by some later collector. I should postulate it is a copy by an early T'ang painter.

Don't think that it is secret and therefore matters not,
The divine ear hears things inaudible.
Think not much of your prosperity: disliking complete-
 ness is the heaven's way.
Rely not upon your honours, things fall from the top.'

Until recently, too, our novels were regarded
as a low branch of literature, because they
treated only of human life, and were therefore
usually prefaced by a moral allegory to appease
the author's conscience! On our birthdays—
days given entirely to rejoicing and amusement
in the West—we are taught that we should at
least spend a little while in quietness to think
upon 'the day when our Father was anxious
and our Mother in pain.' Not only art but
life grows nearer to philosophy in the East.

In Chapter IV I tried to show some of the
ways in which painting and poetry approached
each other. Nature is a great source of in-
spiration and a man may be led equally well by
her to poetry or painting, but the two have
different functions. Painting can best show
shape, gesture, the special nature of living
things; poetry can describe them, it is true,
but the impression is less vivid. Poetry is
supreme for giving us sound and feeling, for
making them explicit. In your fairy-tales you
write of flowers, birds, insects, and all small
things speaking the language of humans, but
our poets live so close to Nature in their imagin-
ations that they remain children in this respect

all their lives. In our poems we write of birds talking their small thoughts and feelings to each other, or holding converse with flowers; painting can only express this by a soundless attitude. Now, by combining both media we may have all our senses fed; there will be two or three lightly coloured birds perched in a tree in the attitude of song; beside them in a poem we inscribe from imagination the words of their singing.

Or someone will paint a flower-bud and describe it by inscription as a little shy creature, unwilling to open her heart to the world, or as one who dreads the inclemency of storms. Immediately the subject becomes a living thing, in place of a botanical specimen, however beautiful in form.

In a bamboo painting by Lo P'in (Plate XXIV) we find a combination of this 'humanising' of natural things with a philosophic symbolism, and the whole expressed in an easy humour—a rare masterpiece in conception. One sees only a few bent branches of bamboo: beside them is written by the artist:

'I had already painted a fence of Winter Plum, when my servant-boy came to tell me that the Monk of "Golden Grain" Temple had bent a row of bamboos into a fence. "Why," said he, "do you not paint the sufferings of the 'long-body-gentleman'?" So I did this for fun!'

Bamboo, with us, symbolises all that you understand by the word 'gentleman', and because of its long, slender stem we often personify the plant itself by the name 'long-body-gentleman'. The servant-boy, with the simple ingenuousness of a child, speaks of the plants as if they were suffering under the monk's treatment, but the master, in his artistic apprehension of the boy's idea, painted a second meaning into them, possibly from his own experience. An appreciative Chinese critic, seeing Lo's picture and reading the inscription, would find in it the symbol of a literary man, suffering under the compulsion of other men; his own character is blameless—he is the 'gentleman', but he cannot withstand the cruelties which the world has forced upon him.

Over and over again in our paintings you will meet with natural objects connoting all the possible ideas which you describe more explicitly with figures; Nature for us does not merely imply a collection of more or less beautiful 'specimens'. I have noticed that in the West you paint your flowers with roots, or else lying in a bowl of water, knowing through science that all things in Nature must have food and drink to live. But the life of our plants is of a different order, neither scientific nor logical. Occasionally we show the roots, but a plant artificially revived in water is a dead thing in

our eyes. Most of our paintings show only stem and blossom; if the brush-strokes are pregnant with life-force, we are satisfied to leave the background a blank; the flower is 'alive' as a man is 'alive' at some moment of sublimity, when earth his dwelling-place and the bread and water of life are alike forgotten.

The inscription is not merely an ornament—that surely is clear; it is a signpost without which the onlooker would certainly lose his way, or never start upon the journey at all. Take a concrete instance: in the painting of Pien Shou-Min (Plate XXII), we see four wild geese disporting themselves in the river; by the bank there are a few water-weeds. The on-looker is chiefly impressed by the vividness of the simple scene, and by the painter's insight into the life of Nature, but if he reads the in-scription the whole picture takes on a new significance. It runs something like this:

'The water seems to grow warmer as Autumn wanes;
Fragrance lingers in the weeds though the flowers fall.
Here and there some talkative wild-geese are flock-
 ing—
Mistake them not for Mandarin ducks, you Passers-
 by!'[1]

Mandarin ducks in China are symbols of love and happiness; they usually swim together in pairs, and remind us of fidelity in marriage.

[1] Translated by Innes Jackson.

But the wild geese are an omen of another sort. Like your swallows, they follow the sun; in Autumn they leave the bitter North and fly to the South of China; when they arrive we know that Winter is approaching. Now you will understand that the sorrow of Winter, of Age, of Night, is hanging over the picture: although the water even seems to grow warmer and the scent of flowers has not left the river, there is no escape from the wild geese's warning!

Or again, take the painting by Fei Hsiao-Lou (Plate VII) called 'Rainy Night'. We see a lady at her window sitting alone in an attitude of sadness, drinking wine or tea; in the corridor her maid is walking with a candle; it seems to be a very quiet night . . . Let us read what the painter has inscribed—a few lines heavy with grief:

'The Autumn rain is falling, falling . . . Its sound disperses among the withering lotus plants. Beside my pillow, deep in the night, how can I bear to listen, now that I have waked from the cheating wine-sleep?'

We realise the whole story: the beautiful lady's husband has departed to a distant province; just now she drank a cup of wine and slept, to forget her sorrow, but deep in the night she woke to hear only the dismal weeping of rain in the decaying lotus flowers, and to see her own lonely pillow; neither wine nor dreams can deceive her at last, and her heart

is breaking. Gradually, as one looks and reads, every attitude, every element in the scene begins to speak the sorrow of long parting. Our painting, poetry, and literature are so close to one another that a picture takes on a new intensity with the light shed on it by a poetic inscription.

Art and scholarship have long represented our aristocracy; we have never had your respect for birth and wealth. Poets and painters formed a kind of 'imaginative' caste, and took delight in one another's talents. Not infrequently you will come across pictures of famous poets in characteristic attitudes with some explanatory writing beside. Yi Ch'ang-Wu's painting (Plate V) provides a delightful example. There was a famous poet of the T'ang dynasty, Li Po, who was more often intoxicated than sober; the story is well known that he met his death by trying to embrace the moon's reflection in the Yangtze river, in a sublime and intoxicated ecstasy. Once he wrote two appropriate lines for himself:

'I am drunk and want to sleep, you had better go away
 now;
 If you care to, to-morrow you can bring your lute
 along again!'[1]

Yi Ch'ang-Wu's picture is a miracle of expressiveness; the corpulent poet is in an attitude of

[1] Translated by Innes Jackson.

drunken oblivion, his head heavy with wine-
fumes, no longer responsive to his musical
friend; one of his attendants is trying to keep
him from falling. There is an atmosphere of
past glory, as if at any moment the scene might
become terrestrial and sordid—that which had
just now been rich in poetry, music, and joy.

The picture by itself would be enigmatic
without the lines of poetry inscribed, and even
those two lines would not give the whole back-
ground of the story, had the calligraphist not
added the circumstances of their origin.

Although the idea of caricature and cartoon
as you have it in the West is alien to us, our
painters too have their lighter moments. There
is a story about one of Su Tung-P'o's poems,
which one of our artists has humorously illus-
trated. A certain Mao Ta-K'ê, also a poet,
had never a good word to say for the poetry of
Mr. Su: one day a friend visited him and they
began to hold high argument on this point.
'At least,' said the friend, 'you can have no
quarrel with his "Lines in Springtime":

"Through the bamboo-grove peach flowers peer—two
 or three blossoms;
Spring water is warm in the stream—the wise ducks
 know it first . . ."[1]

Could anything be more charming?'

[1] Translated by Innes Jackson.

'Pooh!' replied Mr. Mao, in deep scorn, 'it is not even accurate; why, the geese are just as quick as ducks about things like that— that man with his everlasting ducks . . . !'

And so our painter's 'Geese' with the whole story inscribed, is half poetry, half laughter; more artistic than a cartoon, less serious than a philosopher's vision.

Besides the descriptive type, there is quite another category of inscription, which concerns the technique. This variety may seem even stranger to the Westerner, but he should always bear in mind that the Chinese take a keener interest in touch, treatment of brush-work, copying of ancient masters, and so on, than the artist of the West. Thus we come across inscriptions dealing with the composition, the particular style adopted by the artist, or some general discussion of painting theory. Sometimes the painter will quote an opinion of the old masters and add a fresh idea from his own experience. Such discussions may prove stimulating to other artists, and will certainly provide the 'layman' with some 'apparatus criticus' for identifying styles, and tracing the changes in them. Others will explain the reason for their choice of a particular manner, or the length of time they studied art, or even how long they had practised a certain stroke for the painting in question. To you this may

appear a trifle arrogant or at least ingenuous, but to our eyes it merely underlines, as it were, our natural respect for diligence and patience.

I have explained elsewhere that until very recent times we have never painted for commercial purposes; often for pleasure, very often for friendship. In the latter case it is the custom to inscribe the name of the person to whom the picture is presented, and some of the circumstances. We describe the depth of our affection, our sorrow at parting, or simply the day and the season when the painter was together with his friend; in such a personal matter no more need be added. We can hang these paintings in our rooms and keep constantly in mind the memory of past happiness.

In all these instances I have discussed inscriptions written by the painters themselves; there are also those written by others, and they represent a rather different view-point. When an artist has finished a painting and is not entirely dissatisfied with the result, he will rejoice like the father of a new-born son, and hasten to his neighbours that they may share in his joy. 'You may know a man by the company he keeps', is, I believe, one of your English proverbs; we have a very similar one in China. At all events, it is more than

probable that an artist's friends will them-
selves be artists and poets, and one may slightly
twist the proverb from a derogatory to a general
sense. It is quite a common occurrence for
these friends to find a significance in the
painting undreamed of by its creator, to mould
it into poetic form and to inscribe it with their
own hand. Poem upon poem may be added,
each stimulated by the other, until the accumu-
lated 'Meaning' of the picture is almost
unbounded; it becomes a human document of
profound value.

Again, the later owner of the painting may
have a cultured circle of friends to whom he
may hand round his new treasure for apprecia-
tion, and these in their turn may feel a fresh
sympathy with the subject and inscribe their
own response among those of the artist's boon-
companions. Here is an inscription of the calli-
graphist Tung Ch'i-Ch'ang on the painting of a
snow scene by Wang Wei (Plate VIII):

'In the year of T'ien-Ch'i, calculated as Hsin
Yu, Ch'êng Ch'i-Pai brought this painting to
my study, whilst Wang Chu-T'o of Hupeh,
Ch'ên Chung-Ch'un, Wu Chun-Chieh, Yang
Yen-Chung and Chang Shih-Ching of my
native city, Yang Chung-Mu of Soochow, were
all gathered together here. All day long we
looked at it from every angle; without excep-
tion we proclaimed it a work of exquisite genius;

our delight in it was unbounded. For myself, I was like one possessed with envy, but I was happy that it had not fallen into the hands of some vulgar person, and happier still for Wang Wei and his friends.'

During the Ch'ing dynasty this painting came into the keeping of the distinguished art-patron, the Emperor Ch'ien Lung, who added his own comment:

'I have already established beyond doubt that the painting 'Living in Fu-Ch'un mountain' is the genuine work of Huang Kung-Wang. Recently I acquired this "Snow Scene" by Wang Wei. Both came from the collection of Tung Ch'i-Ch'ang in "Hua-Chan" Hall, and so I have added a few broken sentences.'

Clearly this inscription of the Emperor's has no intrinsic value. We are grateful to Ch'ien Lung that he encouraged art so freely, but that he composed bad poems and wrote them in a bad style of calligraphy upon our greatest masterpieces we cannot help lamenting; we must admit that by a false idea of his own talent he has spoiled most of the good paintings in the Imperial collection. Europeans should beware of giving value to a Chinese work merely because it bears the inscription or seal of a famous Emperor; they should withhold their praise until they have judged if the

style, matter and spacing of them are sound
or not.

As a contrast with this pointless ostentation
of the Emperor's I should like to show you an
inscription by a fine artist and gentleman, Ti
P'ing-Tzŭ, written on a figure-painting by 'Old
Lotus' Ch'ên (Plate VI). Although it is a
piece of semi-humorous prose, one may read
it as a poem, and it moves us like a jester in
tears.

'My old friend, Li Mei-An, came to my room
one day and saw this picture; he fell madly in
love with it and said that the figures were as
beautiful as heavenly angels. His face was
long like a Winter-Melon. I jokingly said to
him: "I have heard people say that Wei Chêng[1]
was a handsome man; your face very much
resembles these figures—that accounts for why
you and I see so much beauty in them!" He
laughed heartily and vowed he would write a
long song about it all, but for some reason he
never wrote it, and now he has been dead, alas!
these ten years.'

There is probably a story behind the anec-
dote which has nothing to do with an apprecia-
tion of the painting, but it shows how closely

[1] Wei Chêng was a well-known high official in the
T'ang dynasty of Tai Tsung and a good poet as well.
He was, however, as famed for his ugly appearance
as for his politics. Hence the point of Ti's humorous
comment.

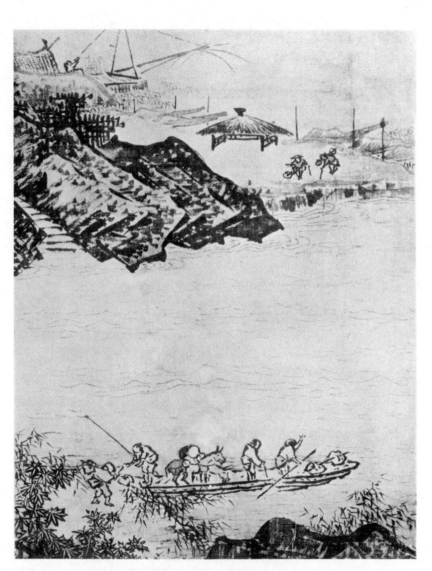

XIII FERRYING ON THE YANGTZE RIVER Hsia Kuei (Sung)
(A part of a very long roll)

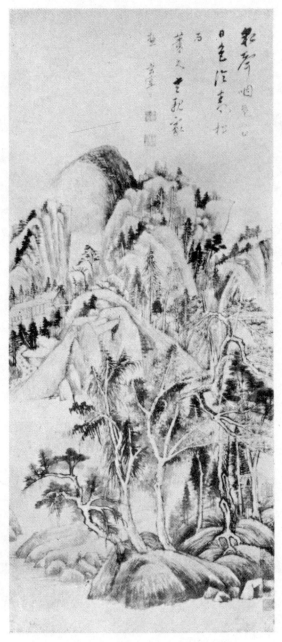

XIV SUMMER Tung Ch'i-Ch'ang (Ming)

art and life are connected in China; the writer of this inscription, on looking at the painting afterwards, would think first of his sorrow for a dead friend, not of the value of possessing an ancient masterpiece, though the first part of the quotation may illustrate the true appreciation of a later generation of artists.

Sometimes the possessor may add some details of the painter's life, if he knows him well, or describe the nature of their friendship, to set a scal, as it were, to this mark of their mutual esteem. Such inscriptions are usually written outside the painting itself, and may easily tend to flattery and extravagant eulogy; they, of all the varieties, are the least valuable to art-lover and critic.

As soon as it became fashionable for the onlooker to make inscriptions, many people who prided themselves upon their elegant handwriting, but had very little artistic sensibility, would hasten to put down some comment without any real understanding of the artist's motives. This is a deplorable proceeding! We believe that the utmost care and thought should be taken by the inscriber to achieve a genuine comprehension of both Manner and Idea.

If, however, these biographical inscriptions are composed with fidelity to truth, the picture will provide the best kind of illustrated

document for studying the artist's life and experiences. Here is an example from a picture of a horse by the famous artist, Chao Mêng-Fu (Plate XIX):

'Chao Mêng-Fu said that when he was young he loved to paint horses. Whenever he could get hold of a sheet of paper he must paint one before he threw it away. That is why, when he had grown up, his stroke was of such outstanding excellence. Kuo Yu-Chih wrote poems about him, praising him above even T'sao Pu-Hsing and Han Kan. On hearing them he just smiled and made no response, really showing his pride. In painting this picture he used the style of "Seal and Bone Character writing", and it abounds with inner vitality; it is indeed worth treasuring highly— inscribed by the recorder Sung Nien of Chin-Hua.'

A comment such as this not only indicates what we should look for principally in the painting, but adds immeasurably to its human value.

Inscriptions are important guides to the collector for testing the genuineness of a work of art. He should be very careful, especially with paintings which have the inscription separately on the mount; it sometimes happens that unscrupulous dealers will separate inscription from painting, fake a second version

of both and re-mount, putting a genuine painting with a false inscription and vice versa, and finally selling both as genuine works.

Again it is a mistake to think that a painting without any inscription is for that reason not genuine: it may be that a certain artist is worried by the trouble of learning calligraphy and poetry composition; tastes and talents are not dispensed equally to all, and he is perhaps so much attached to painting that he chooses to devote all his skill to it. A painter of good feeling knows it is better to leave his picture to speak for itself than to let it stammer halting poetry in an ungraceful manner.

Again, the inscription occupies a definite position in each painting, and its length is determined by the rest of the composition: one picture will call for a long piece of writing, another for a few lines, a third for nothing but a signature; if the artist or collector fails to realise this, no matter how beautiful his hand-writing or how poetical his expression, the picture may still be ruined.

At this point I ought to add a few words about our Seals. Seal-engraving is even considered as an art in China, and the seal-impression an essential element of the picture, as difficult to place artistically as the inscription itself—it has its own particular place and function. The seal is usually engraved upon

stone, jade, horn or ivory, and in ancient characters. Most artists use three for a picture; two for his two names, which he prints after or below his ordinary signature, and one of a more elaborate nature, containing a line of poetry or a philosophic idea. The latter has a separate literary and æsthetic value, and occupies a place by itself, apart from the inscription, on either side of the picture's base.

Our seals always make a clear scarlet impression, and this colour forms a pleasant harmony with the shaded greys and blacks of our Chinese ink; we feel no picture is complete without the touch of bright colour. It is rather like the adding of the eye to the Dragon, which brought the image to life![1]

Unfortunately, there is also a bad side to the printing of seals on a painting: the collector will wish to add his own, to indicate his possession. It will be a little different in form from the artist's, bearing usually the words 'collected by So-and-so', or 'appreciated by

[1] A well-known painter of the Liang dynasty (*c.* 502-556 A.D.), Chang Sêng-Yu, had painted four dragons without eyes on the walls of 'Ease and Happiness' Temple at Chin-Ling. He said they would fly away if he added the eyes, but people would not believe him. Eventually he was prevailed upon to paint in the eyes of one of them. On the instant there was thunder and raging storm, during which this dragon took to flight: when the thunder passed, behold! only three dragons remained on the walls!

So-and-so', etc. Should the painting pass through many hands, there will be an unlovely accumulation. Granted that they would be interesting to the collector himself from an archæological standpoint, to an artist's eyes the picture is overloaded. Chi'en Lung sinned as badly here as over the inscriptions; he scattered his seal on all the fine masterpieces that came into his hands, and seldom with any respect for the composition. One or two eyes are enough for any dragon!

PAINTING SUBJECTS

FROM the 'Historical Sketch' you will re-
member the rough chronology of our painting
subjects: that figure-painting was the first to
rise, that landscape followed it, and that birds
and animals, grass and flowers, were later
offshoots of landscape painting.

There is no question of disputed rank; from
what you have seen of its bond with philosophy
and poetic literature, you will know that land-
scape is Master of Chinese painting. And yet
'Landscape', as you understand it in the
West, is a misleading term; with you it includes
leafy lanes, moorland, ploughed fields, forests,
and downs—every possible aspect of the 'land'.
The Chinese term is 'Shan-shui', literally
'Mountain and Stream', and these two pre-
dominating elements of our well-loved country
have long stood as symbols of all the aspects
of Nature. There seems to be no logical ex-
planation for the choice, but one must believe
that it was not fortuitous. The old, wise
Emperor, Fu Hsi, made Mountain and Stream
two out of the eight main elements of the
Universe, although he might well have in-
cluded the first under Earth and the second

under Water (p. 16). Again you will re-
member Confucius' famous saying: 'The wise
take pleasure in rivers and lakes, the virtuous
in mountains'; 'the wise are constantly active,
the virtuous still.' Surely this pair of natural
elements, complimenting each other, repre-
sent the basic qualities of the Chinese mind;
we love movement, and a mobile flowing
rhythm is one of the chief characteristics
of our brush-work in painting, while its
atmosphere of stillness, quiet and serenity, must
strike the Western onlooker especially, accus-
tomed as he is to scenes of strenuous action.
However this may be, you will find that all
our so-called landscapes represent mountains
and water in some form, perhaps a waterfall
pouring from a high peak into swirling clouds,
for the Chinese artist often takes his imaginary
stand on the mountain crest rather than on
the horizon's line, or on a small craft afloat
under the shadow of a towering precipice.
Many a time our artist's 'Shan-shui' will be
a scene that the human eye has never looked
upon—a simplification of natural form to em-
body some particular thought, or an imaginary
world constructed out of the wise and still in
Nature.

In this chapter I want to discuss Landscape
in a little more detail than I have yet done,
and the other main divisions of subject-

matter at the same time. I shall keep the chronological order and begin with figure-painting.

FIGURE-PAINTING

We may assume that figure-painting rather than landscape came into prominence in the early centuries of our civilisation for the reason that art in general was in the service of a governing Emperor, not an art patron. Under the Chou and the Han the rulers were intimately concerned with public affairs, with practical administration, with social morals; 'art for art's sake' was a catchword that was long to remain undiscovered. We have no surviving pieces from the earliest days, but we are told that the Chou emperors were kept in constant mind of their duty to Virtue and their Heaven-appointed place by having the portraits of good and bad emperors from the past constantly before their eyes, a double-edged warning.

During the Han dynasty art began to leave the exclusive air of the Palace and to concern itself with public morality. Stone engravings were one of the most characteristic forms of expression at this time: we know of one very famous one called 'Confucius asking Lao Tzŭ about the Rites'; the sage is consulting his compeer in wisdom on the right methods for

conducting the affairs of the world and keeping a proper order in society. It is a more terrestrial version of Moses with his Tables of Stone.

The Han figure-paintings fall roughly under three headings: that which we call 'transposed' description, realistic, and idealistic. The first division includes stories of human life taken from History or the Classics, and of the lives of ancient emperors and philosophers. The second is concerned with the portrayal of social customs, of the costumes of a certain period and so on; the third with legends and myths, stories of dragons and the fabulous phœnix[1] in their relations with the fortunes of man. One may remember Confucius' lament in the 'Analects':

'Alas! The phœnix does not appear, and the symbol does not rise from the river. There is no hope for me!'[2]

This type of subject would be likely to appeal to the Han artists, connected as it is on the one hand with the practice of social virtue, and on the other giving scope for imaginative treatment.

[1] Both the Chinese Phœnix and the Symbol are said to arrive when the right principles are triumphing in the world. The symbol is concerned with the Pa Kua of Fu Hsi; a strange monster headed like a dragon and with the body of a horse is supposed to have risen from the river with the symbol marked on its back.

[2] Translated by S. I. Hsiung.

Gradually, as Society fell from a state of order and peace, the painters turned from historical to religious subjects; for a long period of years, especially from the Northern Wei to the T'ang dynasties, the outstanding works of art were devoted to Taoism and Buddhism. In place of the lives of ancient emperors the artists drew events from Buddha's and Lao Tzŭ's life, and the legendary pictures were very often connected with them rather than with historical omens. The favourite Buddhist subjects for figure-painting were portraits of the eighteen Lohans (or Attendants) of Sakyamuni, of 'The Buddha of Endless Longevity', of Kuan Yin, the Goddess of Mercy, and of Lao Tzŭ characteristically represented as seated on an ox. Plate II gives us a good example of this type of subject. It was painted by a Sung dynasty artist, Ch'ao Pu-Chih. It is said that the Sage, after striving all his life to relieve the people's sufferings by leading them back to free and natural manners, in his old age despaired of his labours. It was an obstinate generation that would not be saved, he said. So he rode away through the Han-Ku pass, carrying with him his secret of happiness, and was never seen again, though men say he still lives. Ch'ao Pu-Chih could well interpret the Sage's attitude, for he himself had spent his life in public

service, and in old age left the world of affairs to follow the simple life of a Taoist. The whole essence of Taoism is expressed in his picture; the ox seems to have been in difficulties, but Lao Tzŭ still smiles gently: uneven pathways, burning heat or shrivelling cold, what can they matter to him who discards the World, who is possessed by an inward happiness and security?

'Those who have unbounded virtue are to be compared with babies, whom poisonous insects do not sting, beasts of prey do not seize, and carnivorous birds do not attack. Their bones may be weak and their muscles may be soft, but their grasp is firm.'[1]

The proportions of the animal and human figure are not in keeping with reality, but the whole conception is alive and eloquent, even to the tree branches and leaves. Notice especially the forelegs of the Ox, how full of movement! In China we think the chief characteristic of Ch'ao's painting and poetry is their combination of strength of expression with ease of atmosphere.

Lao Tzŭ himself is not the only subject of Taoist paintings; we often see represented the Western Queen Mother, a glorious legendary figure of the Taoist hierarchy, or the Sage, Chuang Tzŭ, with his butterflies—Chuang Tzŭ

[1] 'Tao-Tê-Ching', translated by S. I. Hsiung.

who thought ox-riding in the Western regions was not 'free' enough, but dreamed of becoming a butterfly with all the world to fly through. Your English poet, Spenser, once dreamed of this same happiness of becoming a butterfly with shining rainbow-coloured wings, free to enjoy the lavish beauties of the earth:

'What more felicity can fall to creature,
Than to enjoy delight with liberty,
And to be Lord of all the works of Nature,
To reign in th' air from earth to highest sky,
To feed on flowers and weeds of glorious feature?'[1]

Spenser's dream was perhaps more a poet's than a philosopher's paradise!

At the outset, the paintings of Taoist and Buddhist figures were made for a specifically religious purpose; frescoes were put round the walls of temples to give the buildings an atmosphere of reverence, and portraits of the Buddha especially were hung up for the people to worship, a symbol of divinity. This was the time when Chinese artists were imitating directly from Indian examples brought from India by Buddhist monks. As the religion began to adapt itself to the Chinese mind, the paintings tended more and more to represent a personal philosophy of the artist in the place of a traditional religious idea. They took on

[1] Spenser, Muiopotmos, st. 27.

Chinese characteristics; the figures were simpli-
fied, especially in the treatment of drapery, and
the facial expressions were more dignified, im-
mobile, unworldly. It was, in this stage, a
form of art very profoundly respected by our
people, for the standard of success was a high
one. It was the artist's aim to express all the
attributes of the Divine Character in the face
and form of his painting—mercy in combina-
tion with sternness, compassion, renunciation.
And yet these qualities should not be entirely
'expressed'—they should be innate only, so
that the devout worshipper and not the mocker
might perceive them.

The Zen (or Ch'an) School of Buddhist
thought drove Chinese Buddhist painting
further and further from popular religion
towards individualism. Zen believers said there
was no need for images: one had only to medi-
tate with faith and the true Buddha would
enter one's own heart. At this point, religion
is ready to leave figures for landscapes: instead
of an improved form of the god, the onlooker
is provided with a quiet scene in the contem-
plation of which he may lose his awareness of
the earth and find the god within himself.

Wu Tao-Tzŭ's is the name chiefly associated
with the conversion of Buddhist painting from
images to the literary side. Yen Li-Tê and
Yen Li-Pên are also famed in the T'ang

dynasty, and 'Sleeping Dragon' Li in the Sung.

Although religious subjects predominated, the Han tradition of depicting human affairs and customs, if less highly respected, was yet still maintained all this time, and continued even after the rise of landscape art. Indeed, during the T'ang period when some of the greatest masterpieces of landscape were being produced, this type of picture was especially popular. Turkestan, Tibet, and Mongolia, with their strange customs, were coming within range of the Chinese vision; there were many paintings of these bordering races in the T'ang collections. Some of the favourite subjects were horse-stealing, the feeding of camels, hunting, bird-catching, and the nomad life in tents. They reflect the fashions of the time. Although very few examples of this type of pictorial work have survived, we can assume their existence from the evidence of T'ang pottery figures and animals.

On the other hand, familiar scenes of domestic life were not lacking—scenes of bare simplicity such as the cutting of firewood, fishing, listening to a canary, or the mild excitement of a cock-fight. In the Sung dynasty there was a general tendency towards realism; the strange ceased to interest in the same degree, while the familiar was portrayed

with added poignancy or humour. Plate III
shows a painting by the Sung artist, Li T'ang,
of a common human event, a physician's
visit. The composition is strikingly good—the
man screaming with pain under the physician's
touch, his wife holding his left hand in an atti-
tude of extreme distress, his two daughters
trying to support him on the other side. With
determination the physician sticks to his work,
regardless of the family's terror, while his boy-
servant takes out a salve in preparation for his
use. Each expression differs, but even to the
wind-swept willow every element of the scene
spells dismay; there is an unmistakable inner
harmony of feeling.

Stories of ancient dynasties were still painted
occasionally, especially to show the beautiful
costumes of old times. On this point too we
love antiquity, and think the painting of
figures in modern costume of very little value.
Incidents from the lives of noble families were
sometimes depicted—their sports and enter-
tainments—or incidents from the careers of
famous poets and men of letters; even a small
anecdote about a literary man we paint over
and over again if the nature of it appeals to
our imagination and seems to signify some-
thing more than the event itself. The paint-
ings of Li Po in his cups are numerous; our
painters may have thought that some spirit lay

in the wine to carry our corpulent poet into such exalted regions. Or again, you will meet many representations of that other great T'ang poet, Mêng Hao-Jan, riding over the snow on a donkey looking for plum-blossom. We paint this scene as a symbol of our admiration for the type of character which chooses to forsake bodily comfort and to go out in search of beauty. Sometimes we catch our great men in a humorous predicament; poetry-making is such an everyday affair in China that we do not need to put our poets into glass cases, or treat them in a sort of 'noli me tangere' attitude. There is a story, for instance, of the Sung poet, Su Tung-P'o, who had a special 'penchant' for peach wine: one day he came to visit Fo Yin, the poet-monk, with his fellow-poet Huang Shan-Ku, and noticed a barrel from which seemed to emanate the odour of peaches. At once he demanded that cups of it should be set before them, only to find that the barrel had contained peach vinegar. The sequel to Su's avidity—three unwary gentlemen screwed into horrible contortions—has provided more than one painter with a good subject for his brush.

Scenes from the lives of ladies form a large division of our figure-painting; their graceful motions and flowing draperies are particularly suitable for the type of movement that grows

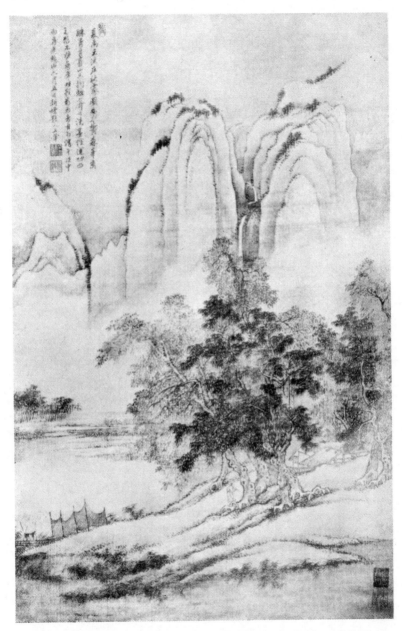

XV AFTER THE AUTUMN RAIN Wang Shih-Ku (Ch'ing)

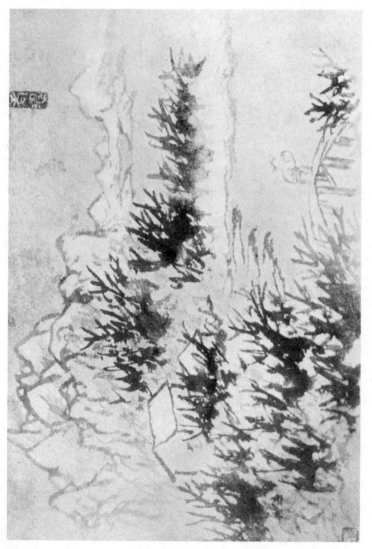

XVI SNOW SCENE Shih T'ao (Ch'ing)

under our style of brush-stroke. Some we take
from tales of famous historical personages,
particularly the Lady Yang Kuei-Fei, the
beloved of the Emperor Hsüan Tsung and the
most celebrated Chinese beauty of all times.
Other scenes are taken from narrative poems,
or simply from life—a group of charming girls
taking tea in a painted pavilion; a solitary lady
leaning on a balcony lost in thought; another
playing on a pipe or lute or guitar, or in the
act of painting a delicate landscape. Some
artist may choose to put his lady into the shade
of a bamboo grove where she seems to be en-
joying her solitude on a warm summer's day;
or again, she may be playing with her parrot,
or looking at her small face in a mirror, or
reading a book with a stick of incense burning
beside her. The picture entitled 'Hors de
Combat' by the Ming artist, Ku Yün-Ch'êng
(Plate IV), is a very delightful example of this
type of painting: the lady has let her head and
arms sink on to the table in an attitude of ex-
haustion, but though she is weary she does not
seem to be sad; it may be that she has pored
over books of poetry till her head is confused
with a host of lovely images, and she can no
longer bear the prickings of their gentle beauty.
It is a happy exhaustion like that of a small
wave which has lapped too many times on
to the shore, and is now swept back into the

comfortable arms of the Great Sea. The brush-strokes here are of especial fineness; notice how exquisite they are in the forming of bowl and books. The composition is so good and the whole movement of the painting so expressive that the added inscription is really superfluous.

Some legendary stories, of quite another sort from the Dragon and the terrifying spirits of the old days, are popular subjects for our figure-painters. There is the well-known fable of the herd-boy and the weaving-girl who were banished from earth by the Jade Emperor for no greater crime than love, and who became two stars on either side of the Heaven-River, as we call the Milky Way. Once a year, on the seventh day of the seventh moon, all the blackbirds are supposed to assemble in the sky and form a bridge over the Heaven-River so that the two lovers may meet. Some-times we paint the sorrows of the weaving-girl and her herd-boy, or their love story, or the joy of their meeting. Or we may paint scenes from the Festival ceremonies that take place on this day. Young girls are in the habit of worshipping the weaving-girl to pray for skill in embroidery; they burn incense to her, and try to thread fine needles by moonlight for an omen. Scenes of this nature form quite fre-quent subjects for painting.

We paint children as well as ladies, especially

at the 'Lantern Festival'. This occasion
offers an abundance of varied scenes to the
imaginative artist: it is a time when the
children disguise themselves as animals and
play many curious and fantastic games with
balloons and lanterns adorned with strange
figures.

But whatever story we choose, it is the story
itself and not a convincing likeness in the figures
that we lay stress on, just as in a portrait
or imaginative painting of a human figure we
try to override facial resemblance on the one
hand and strict verisimilitude on the other, and
to seize some aspect of a living personality. I
have told you in my chapter on Inscriptions
how Ti P'ing-Tzŭ and his friend quite fell in
love with 'Old Lotus' Ch'ên's picture of a lady
with her two attendants, and how one of them
called the three of them* as beautiful as the
angels in heaven. This painting is reproduced
in Plate VI, and perhaps you will be puzzled
at such enthusiasm. The figures are clearly
disproportioned and the faces may not entirely
conform with traditional ideas of beauty, but
'Old Lotus' was a genius beyond any doubt,
and when you become more accustomed to his
style, harder perhaps to appreciate than Ku
Yün-Ch'êng's, you will be suddenly aware of a
certain dignity and grace that transcend mere
beauty of proportion, and which we usually

associate with that other beauty of character and life.

The Chinese expression for 'portrait' is 'Chuan Shen'—'to transmit spirit'; I venture to think it is as expressive as the 'Shan-shui' for landscape. The records speak of good portraits by very ancient masters and describe them as being close likenesses, but later practice does not substantiate the claim. We have another expression, 'Hsieh-Chên'—'to write truth', which corresponds more closely with the Western idea of portraiture, but it is a much later development in style.

I should point out that we very rarely draw directly from a model or sitter, as is the custom in the West, though our ancestor portraits have some relationship with this type of painting. Every family likes to keep a portrait gallery of its ancestors. The picture is painted while the person is still living, and on his death is hung above his 'Tablet' where his life and virtues are recorded, and his descendants offer worship to the painted image to signify their trust in the perpetual life of his spirit. These portraits are seldom made by the great masters, but by secondary artists who specialise in them, and they will paint from a close observance of the person, but not line for line, measurement for measurement.

The good portrait-painter will like to live

under the same roof as his model for several days, or even months; he will watch his movements, his changing attitudes, his varying expressions; he will study his habits, character, temper. At last he will take up his brush and get to work from the idea he now has in mind, striving to give expression to the essence of the man's character and to the generalised framework, so to speak, of the man's bodily form in all its aspects. We use only a clear line for portraits, bearing out the ideal I have just suggested; the sketches of Holbein have some resemblance to them. The portrait of Confucius by Ma Yüan (Plate I) of the Sung dynasty will illustrate my point: the artist must have drawn the Sage from studying his philosophy, for no contemporary likenesses have been preserved; the general impression is one of deep gravity and thought—Ma Yüan has exaggerated the height and bulk of the forehead for this purpose. Like Tao Lzŭ on his ox, this Sage too wears a gentle smile. The same mysterious smile is one of the most common attributes of Buddha's portrait, whether in stone or paint. One must suppose it implies the possession of incommunicable wisdom and inward light; the great Sages remark the follies of the world and look on them as pitiable shortcomings of heedless children. This is perhaps the Mona Lisa's secret also! Notice particularly the strokes in

the folds of the robe; they are of a type peculiar to this painter. These brush-strokes of the drapery are of great importance in our eyes; we judge a good portrait first by the whole composition and secondly by the type of brush-work in the dress folds (I-Chê). There are roughly two kinds of treatment, the bold and the delicate, but the strokes themselves are of many shapes and formations; we give them a variety of picturesque titles such as 'iron-wire', 'willow-leaves', 'orchid leaves', 'dry firewood', 'nailhead and mousetail', and so forth. From Plates I-VII of this book I think you will be able to distinguish a great number of different strokes in the drapery.

As for backgrounds, the majority of our portraits have no accompaniment of furniture, curtains, ancestral houses or pet animals, nor are they set against a landscape; we prefer on the whole to let nothing distract from the figure itself. There is, however, another type of painting where a figure is added as a supplement to landscape scenery; sometimes the figures are more prominent, sometimes they are dwarfed by a powerful aspect of Nature, but in every case there must be a harmony of treatment and feeling. Should the strokes of the human figure be too bold or too delicate for the landscape background, the whole picture will be ruined. Plate V offers a good example

of this type of painting, an eminently successful combination.

The general atmosphere of a landscape is 'Quietness', although there may be motion in it; our intention is to shadow forth the beauty of an ideal world, not a particular mountain or an actual river, but an imaginative representation of Nature in essence, in which appear only those characters of poets, artists or simple peasants that would harmonise with the spirit evoked.

One of the most greatly admired kinds of figure-painting is that which we call 'written figure', and is composed of only a few strokes brushed on to paper with a flying motion. This kind of figure may have no eyes and yet seem to look at something, have no ears and yet appear to be listening intently; although there are few actual strokes, many others are suggested to the onlooker's imagination; it is a type which calls for undisputed genius.

LANDSCAPE

We have no evidence of the existence of landscape art in China before the Chin dynasty (A.D. 265-419) although it seems likely that there were attempts at landscape backgrounds to figures before then. Ku K'ai-Chih, the famous figure-painter of the fourth century, has been acclaimed as Patriarch of this branch

through one small section of his roll, 'Admoni-
tions of the Imperial Preceptress to the Ladies
of the Palace.' Here, it seems, is the first
piece of natural scenery; it shows a mountain
inhabited by a number of wild beasts: the
animals are so large in proportion to their
habitation that one might almost imagine
their gobbling up the whole mountain between
them for their supper! But as we study the
painting we are not troubled by perspective or
verisimilitude; we are only aware of a mind
that can detach itself from humanity to con-
ceive the life of wild places, and of a hand that
can command a living stroke. His 'On the
Painting of Cloudy-Terrace Mountain' is also
the first discoverable written work on Land-
scape.

Tsung Ping of the 'Northern and Southern
Dynasties' (A.D. 420-617) succeeded Ku, pro-
viding a good commentary on the art in his
essay, 'Preface to Landscape Painting'; he writes:

'The greatness of K'un-Lun Mountains and
the smallness of the eyeball are incomparable.
The complete form of the mountain cannot
be seen when the eye is quite close to it, but
from a distance the eye can take in its whole
compass, since the size of the mountain dimin-
ishes as it recedes from sight. Now we can
hold the mountain within a small square of silk:
three inches of brush-stroke may represent

thousands of feet of height, and a few feet, hundreds of miles of distance . . .' In this paragraph Tsung Ping has summed up the essence of our landscape methods. Hsia Kuei of the Sung dynasty has only followed Tsung's precepts when he undertook to paint 'The scenery of ten thousand miles of Yangtze River' on a scroll a few feet long. His river has no resemblance to a short stream, even for the most sceptical onlooker; from the small portion reproduced in Plate XIII you may feel the painter's mastery over his medium; he identifies the power which keeps Nature working in fullness, unity, and balance.

All this time artists had been experimenting in treatment, and it was not until Wu Tao-Tzŭ of the early T'ang dynasty that landscapes began to be painted with a confident assurance of stroke. During the 'Six Dynasties' and the very early days of T'ang, scenery was described with a very delicate type of brush-work; with the increasing popularity of this class of painting, various books of theory were composed and methods of treatment invented, and eventually Wu Tao-Tzŭ arrived with his strong, unhesitating genius to enfranchise the brush-stroke and set the example for broad bold treatment. Simultaneously a second artist, Li Szŭ-Hsün, invented another type of landscape, painted with rich deep colouring.

In the course of the T'ang period, landscape entered its flowering season (A.D. 618-906); there were two main Schools which we call 'Northern' and 'Southern', differentiated not by geographical position, but by the treatment of brush and ink. In our eyes the most essential elements of landscape painting are the composition of the whole and the brush-work, or the individual treatment of the parts. Our young artists will spend many of their early years of training in copying a variety of treatments that have been accepted as suitable for certain subjects—pines, rocks, waterfalls, and so on; styles that have been sanctified by the practice of Old Masters. Only after a thorough grasp of these will they venture on a style of their own, in conformity with their personality.

Li Szŭ-Hsün was the founder of the Northern School: he and his followers favoured a strong, severe form, and enforced a design, leaving little to the onlooker's imagination. As in figure-painting, we have special names for the different types of brush-stroke—'hemp-fibre', 'folded-belt', 'bullock's hair', 'lotus-veins', 'Mi-dots', 'axe-cuts', and so on. In general the Northern School used the rugged types, such as the 'axe-cut', while the Southern chose more readily the 'hemp-fibre', 'lotus-vein' and others of a graceful kind. The

latter was founded by Wang Wei (A.D. 698-759) whose picture 'A Snow Scene' we reproduce in Plate VIII. The followers of this School are chiefly characterised by their freedom of treatment; their paintings are 'poetic' and imaginative, tending to abandon a literal representation of form; the basic design is not emphasised and great opportunity is offered to the 'Rhythmic Vitality' to expand itself freely. The reproduction is interesting from several points of view: there are very few genuine relics of T'ang paintings remaining, and the authenticity of this one by Wang Wei is undoubted: we can judge of it not only by the manner of the painting itself, the condition of the paper and ink, etc., but also from the inscriptions. We have the words and signature of Tung Ch'i-Ch'ang, the Ming painter, a typical example of the Emperor Hui Tsung's writing, and finally the assent of the Emperor Ch'ien Lung (p. 126). Secondly, by a careful study of the strokes you may realise that this is an early work of the artist, when he was himself a half-hearted follower of the Northern School and was already beginning to develop that individual style which eventually resulted in his founding of the Southern School with its opposing traditions. The lines of the pavilion roofs, for example, are strongly described in the tradition of the 'Northern' artists, while the

general contours of the mountains are soft and suggestive, in keeping with the new 'Southern' ideals.

This was a momentous period for Chinese landscape art: two outstanding manners were established which prevailed with individual adaptations right up to the present day, though it has been an increasing tendency to follow Wang Wei's side. The fashion set by Li Szŭ-Hsün and his son Li Chao-Tao, for painting richly coloured landscapes has continued; the type attained a special beauty under the brushes of Ma Yüan and Hsia Kuei of the Sung dynasty, though for the most part our Great Masters are content with simple shadings of black ink for their medium. As the brush-strokes became the distinguishing feature of the different masters, so colours naturally grew insignificant and unnecessary.

Among the chief exponents of the Southern School during the Sung dynasty were Li Ch'êng, Fan K'uan, Tung Pei-Yüan, and Mi Fei: at this time we find landscape at its richest and fullest —rich and full in output, innovation, master-pieces. I hope from the illustrations, Plates VIII-XIII, you may be able to study some of the main varieties of treatment. To choose any single one as typical of so long a period would be rash, but perhaps the small snow scene by Liu Sung-Nien, which I am unfortunately

unable to reproduce, may claim to embody the treatment and feeling generally associated with the 'Southern' School of Sung. There is first 'literary' content—mountains, little bridge, lonely pavilions, desolate willow-tree—each of the elements is almost vocal with the mingled beauty and bitterness of winter: someone might remark that it was a 'poem in paint'. The composition also illustrates the early Sung masters' inclination to fill the surface of the painting sheet, and to amass circumstantial evidence, as it were, of reality—describing natural forms in careful detail. Later there arose a general movement away from explanation to mere hinting, from the crowded canvas to the sparse. It is illuminating to see the later Sung masterpieces with large areas of empty space occurring as part of the composition, while only the topmost peaks of a few mountains are limned in, or a single leafy spray of peach blossom or other flower. Ever since, SPACE has been the most outstanding characteristic of our landscape painting.

Fan K'uan, painter of 'Sitting in Contemplation by a Stream' in Plate X, shows the typical Sung brush-stroke of the 'Southern' School; it is powerful, carefully formed, and sticking closely to the medium; however thin, each line is a sure one from tip to tip.

Two more 'Southern' painters, Mi Fei and

Tung Pei-Yüan, illustrate some interesting
varieties of presenting a mountain (Plates
XI and XII). Mi's character, in particular,
was well in harmony with the strength and
rigidity of towering peaks—he was deeply in
love with the rugged aspects of nature. A
story is told of him that when he was once
walking in the Wu-Wei district of Anhui, he
saw a very large rock in his pathway; it was
grizzled, strangely shaped, quite ugly to look
at, but Mi suddenly felt his heart go out to it,
and, finely robed as he was, knelt down in the
dust and called it 'My elder Brother!' For
this he became known as 'Mad Mi', but now
we understand that kind of witlessness. His
mind was not in sympathy with the delicate
brush-work of his contemporaries, especially
the flower painters—he would refuse to paint
even a single stroke on silk, and would use the
roughest instruments for his tools, such as a
piece of old rag, a stick of dry sugar-cane, or
a lotus-stem in place of a brush. His chief
innovation was the 'Mi dot'; you may see
from the illustration (Plate XI) that in place
of the usual succession of curved, sweeping
strokes with which mountain scenery is de-
scribed, and which we term 'wrinkles' (see
Plate X, for example), Mi has used an accumu-
lation of dots applied with a rather wet
brush; it is a species of brush-work which

subsequently became very popular for the depiction of rainy or misty scenery.

Tung Pei-Yüan's work is well worth careful study; he was the first to strike out a definite path of his own, under the wings of the 'Southern' School certainly, but free from the domination of its founder Wang Wei. When one considers that he was a man of the tenth century, one may well be amazed at the resemblance of his treatment to that of the nineteenth century French Impressionists; the clear forms, deliberate strokes, vivid contours are particularly striking; it is certainly possible that Impressionism would have started earlier in Europe had her artists been more familiar with our Chinese masters. Here is a 'dot' indeed! We must acknowledge that he was a bold man who could use such a big one, but we feel the master's controlling hand—not one more nor one less is desirable anywhere in the picture. Ching Hao and Kuan T'ung, of the Five Dynasties, were the originators of the style, though there were already some hints of it at least in the work of Wu Tao-Tzŭ of T'ang, but a Tung Pei-Yüan was needed to give it the ideal expression. From the painting you will notice how Tung's touches of bold blackness force the shoulders of his mountain out before your eyes! And all without the help of realism: it is 'painting

pure and simple' in the literal meaning of the term.

Such were the main characteristics of the 'Southern' School of Sung, opening up a host of possible directions for succeeding artists. The 'Northerners' were also very active at this time, under the leadership of Ma Yüan and Hsia Kuei. You will remember from a previous chapter how these two adventurers, while keeping the traditional severity of the 'North', simplified the Composition, and gave freedom to the picture's movement. Ma Yüan particularly was satisfied with a small piece of scenery for subject-matter, very lavishly spaced—the phrase: 'A remnant of mountain and a residue of water' in no derogatory sense, is often quoted about him.

In spite of the new infusion of life which these two artists provided between them, the 'Northern' School has grown progressively less prominent in our painting practice; Tung Ch'i-Ch'ang, a well-reputed painter and art critic of the Ming dynasty (A.D. 1368-1643), passed the opinion that the style of the 'Northern' School was to be rejected, and that of its rival alone deemed worthy of appreciation; from about that time onwards the former was much less in favour with Ming artists than the latter. Tung Ch'i-Ch'ang himself was a man of re-markable significance: he was Minister of

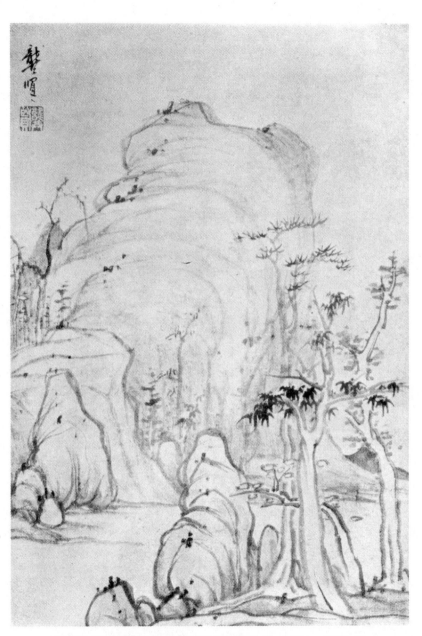

XVII PEACE, PERFECT PEACE Kung Hsien (Ch'ing)

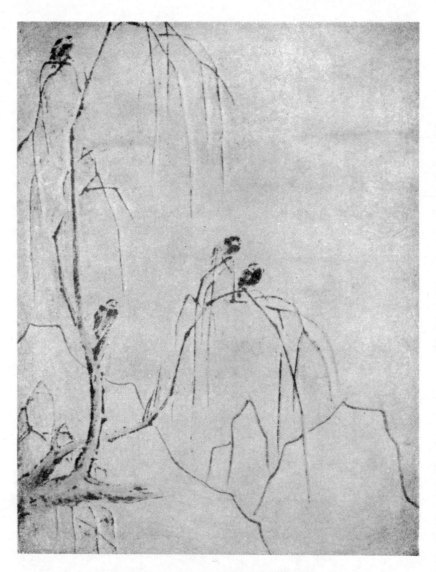

XVIII BIRDS ON WILLOWS Hsiao Chao (Sung)

Rites—a sort of Home Secretary one might say
—a calligraphist, a poet, an art critic, a con-
noisseur, a progressive artist. When you look
at his picture entitled 'Summer', reproduced
in Plate XIV, you might be tempted to exclaim
at a first glance, 'Cézanne!' And yet Tung
Ch'i-Ch'ang lived and worked five or six cen-
turies ago! How similar is their treatment of
tree branches, for example—angularity in com-
bination with the free expression of a living
thing. Both of them illustrate the painter's
mastery over Nature, the exertion of 'action-
less activity'; placing and contour are in con-
formity with the artistic idea, not the reality of
Nature, and yet the artist has captured the
intrinsic liveliness of his natural objects and
given them that added life which emanates from
the creative mind in the heat of vision. This is
the 'Southern' ideal in its latest manifesta-
tions.

Apart from Tung Ch'i-Ch'ang, a few names
such as T'ang Yin, Shen Chiu, Wên Chêng-Ming
and Ch'iu Ying stand out as masters of the
Ming period. T'ang Yin's landscape painting
showed an inclination towards the 'Northern'
School. Wên Chêng-Ming was a painter of
very high culture and lovable disposition: never
willing to paint for the rich and noble who
were ready to offer him adulation, he preferred
to present his masterpieces to poor people who

befriended him with more of nature and less of art, providing him in return with the necessities of life when he absent-mindedly forgot to make provision for them.

During the Ch'ing dynasty, landscape painting seems to have fallen back upon the early models of composition, yet without showing any distinctive brush-work of its own. I have mentioned the 'Four Wangs' before, but they were only good painters, not masters. However, Pa-Ta Shan-Jen and Shih T'ao distinguished themselves through their increasingly simplified treatment, their bold and free brushwork, and their creative power in shaking off the traditional forms of composition. The illustrations, Plates XVI and XXI, serve as illuminating examples.

The Chinese persist in certain conventions which may always remain peculiar to them: Wang Wei of T'ang gave some general outlines which remain guide-posts more or less even to the present day. He writes:

'When painting landscapes, use more your instinct than your brush: allow ten feet for mountains, a foot for trees, an inch for horses and a tenth of an inch for human figures; no eyes are necessary for distant figures, no branches for distant trees and no rocks for distant mountains, which resemble indistinct eyebrows, and no waves for distant waters

which are as high as the clouds—this is the key for painting. Clouds cover the middle of mountains, waterfalls cover part of the rocks, trees cover towers and pavilions, and figures cover the roads . . . these are the methods of painting. . . . When there is only wind but no rain, attention should be paid to the branches of trees; and when there is only rain but no wind, the treetops are bent down. . . . A morning scene is represented by a thousand mountains brightening up in the dawn with light mists, and an evening is revealed by showing the setting sun behind the mountains. . . .'

We have thus conventional symbols in paint as in poetry; certain colours to indicate certain distances, certain shapes for the same reason, certain movements to show certain natural reactions, certain treatment for October, for March. . . . They are unconsciously accepted by us through long tradition; to the Westerner they may not pass unquestioned.

Just as we repeat over and over again in poetry the characters for such forms as flower, moon, wind, that tradition has decided are richest in poetic association, so we introduce the customary elements into our landscapes, even in the most modern examples: they are— besides the basic mountain and water—rocks, trees, clouds, and frequently moon; pavilions,

small figures, bridges, and boats are not infrequent adjuncts, but you will rarely find any other components.

There are three modes of painting mountainous scenery. The first is called 'Kao-Yüan' and is the most common especially in ancient paintings: the artist imagines himself at a little distance from the mountain and is looking up towards its peak (Plate X). The second, 'Shen-Yüan', means literally 'Deep-distance', and implies that the artist imagines himself in front of the mountain range, looking at the peaks one behind the other. The third, 'P'ing-Yüan', 'Level-distance', indicates a landscape in which the artist is situated on a peak and looking at other peaks on a level with himself.

Streams are also divided into certain categories—'Flowing-stream', 'Foaming-stream', 'Flying-spring', 'Hidden' and 'Hanging waterfalls', 'Folded-spring', and so on; each term is sufficiently expressive.

You may now perhaps realise the full significance of the almost hackneyed saying in Chinese art that the great painter must 'travel ten thousand miles and read ten thousand books': without a sure and acute and personal observation of Nature he will merely be able to reproduce a lifeless formula; without a grounding in general culture, in

poetry, in the artistic conventions I have explained, his brush will betray the erring wilfulness of a child who thinks he can run before he can walk, or learn geometry without Pythagoras!

FLOWERS, BIRDS, ANIMALS, INSECTS, FISH

Man, I have said, we regard as only one of Nature's varied manifestations, and less worthy of appearing in the annals of Art than any other element: the fragile beauty of a flower or the graceful motions of a bird in flight rouses in our hearts, an emotion as poignant as any human loveliness or pain. Sometimes we grow quite intoxicated with their colour or perfume and are impelled to give expression to them in our painting and poetry. We generally divide flowers into two groups: Mu-pên-hua or 'flowers of woody plants' and T'sao-pên-hua or 'flowers of herbaceous plants'. The former are admired for their rich colouring, and some for their scent as well; the latter win our admiration through their slender, gentle character and their clear perfume, and many through their bright colours. At the beginning of this branch of art it seemed good to combine a flower with a bird, for wherever birds are singing there are sure to be flowers or flowering trees near by. Later on, flowers

came to be painted singly—a small spray, or even a few petals and a handful of leaves.

As you know, flower painting did not rise until the T'ang dynasty, and we have unfortunately few authentic paintings of any kind from those days: the names of the most highly reputed T'ang flower artists are Pien Luan and Tiao Kuang-Yin. During the 'Five Dynasties' period there was a great forward movement in this very delightful branch of art: Huang Ch'üan invented the method of painting flowers and birds which we call 'Line-contour' or 'Double-line', in which the forms of petals, leaves, stems, or birds are outlined, in contrast with the 'Without-bones' style favoured by Hsü Ch'ung-Ssu of the later period, where each of the different parts is composed of single brush-strokes. For instance, Plate XVIII shows the second of these two types; the birds and willow-stems, though carefully touched, seem to be a thoroughly spontaneous outburst of affection for Nature, not purely decorative, but 'lively' with the life of paint: we may even imagine those birds taking wing from the paper! The two types continue in 'Bird and Flower' paintings, side by side; in Sung the first was chiefly favoured, the latter in more modern times.

Our country is vast in area, our climate varied, our love of the soil very deep; in the

length and breadth of China we may cultivate
an unbounded variety of flowers, and yet we
generally choose for painting a limited selection
—those which have been found by tradi-
tion to be richest in poetic content, and most
lovely in form. Of the flowering trees and
shrubs there are the pear, peach, pomegranate,
apricot, prunus, rose, camellia, magnolia,
azalea, rhododendron; and of herbaceous
plants, the peony, hollyhock, chrysanthemum,
orchid, iris, lotus, mallow, water-lily.

Nearly every flower we paint contains an
inner meaning; our wise and ancient philo-
sophers used to choose natural forms as symbols
of their thought, whether about Nature or
Humanity, or they would write about a living
thing purely in admiration of its beauty. The
tradition of following their thought is sunk very
deeply in our minds: we revere our philosophers,
we love their ideas in relation to Nature, we
desire to unite ourselves with them, and so we
often choose to paint those subjects which they
especially commended. We gaze on a flower
and see in it a beauty beyond its visible form:
we become suddenly at one with the spirit of
the ancient sages.

This is one aspect for appreciating our flower
paintings; but from the artistic point of view, a
symbolic meaning is redundant: our pleasure
may be arrived at purely from the composition

and manner of treatment, provoking an entirely fresh inspiration, a new version of Nature. Yün Nan-T'ien has a painting of the 'Five Pure Things' which gives an illustration of symbolic flower-art in an obvious form: the five natural things, water, rock, bamboo, pine, and plum-blossom are traditionally possessors of the element of 'Purity': to show their love of a blameless character our artists often choose to paint all five together. Yün Nan-T'ien was an artist of the early Ch'ing dynasty who specialised in flower painting, and his treatment of a difficult composition is quite remarkable. Superficially, from the point of view of material form, the five objects have little in common; bamboo long and sharp of leaf, pine-needles in softly arranged tufts, plum a small elegant flower on stiff bare stem, rock and water of contrary nature and with no logical bond with any of the other three! How to bring them into harmony? And yet the artist has achieved it. He has not accepted a merely conventional symbolic idea, but has found for himself that common quality of them all which the sages called 'Purity' or 'Blamelessness', and from his vision created the old conception afresh; he has communicated with the ancient sages! Yün Nan-T'ien was a landscape painter by preference, but he was a great friend of Wang Shih-Ku, the prolific artist of

natural scenery; to avoid rivalry in friendship, he humbly avowed that he could not compete with Wang, so turned to painting flowers. Posterity says Wang was 'an honest painter' but Yün a 'genius'.

The painting of trees is closely allied with that of flowers: our most frequent subjects are bamboo, pine, and willow, peach and winter-plum, cypress occasionally, and mulberry and cassia; each has its own symbolic meaning and each its artistic loveliness of form—sometimes the one aspect may predominate, sometimes the other. You will remember the 'sufferings of the long-body-gentleman' in the inscription, applied to a bent bamboo fence, and that bamboo, pine and plum are symbols of purity; willow also has its own meaning, often a sad one, implying parting. Our artists often paint a pine or a bamboo to show their own high character, as well as in admiration of the rhythm in their composition.

In the West I have noticed that you like to paint trees with a regular, balanced, graceful outline—a well-formed elm, for example, in lordly stance among your parklands. They illustrate one kind of rhythm, to be sure, but in our eyes it is perhaps a little too obvious, and unnatural besides: we seem to see the forester lopping off branches here and there to satisfy the demands of perfect symmetry. We ourselves

love to see them appearing to grow quite naturally, even with curiously twisted branches, almost distorted by imaginary winds, storms or inclemencies. We like a tree to have personality, a shape full of character, before we single it out for painting.

Very often we put insects together with flowers, and birds with trees, for so it is in Nature; philosophically we do not consider insects as either despicable for their humble size and office, or in any way odious or unclean; they are of equal value in their own sphere as is man in his. Our painters think that both insects and birds are worthy of his considered attention; he does not 'botanise' them, but he tries to understand their ways as he would study the tastes of his friends— learning, for instance, the plumage of birds at their different seasons, the varying habits of mountain, field and water dwellers, and the suitable environment of each.

I cannot say that we paint 'all the birds of the air', but in comparison with Western practice we have quite a vast congregation: eagle, hawk, and peacock; the goose, the duck, the cock and hen; sparrow, dove, swallow, and oriole; crow, magpie, wagtail, cuckoo, heron, and canary; seagull, golden pheasant, quail, partridge, and even the mythical Phœnix! What a galaxy! We see nothing comic in the

duck, nothing incongruous in painting a wag-
tail or a goose; they are all children of Nature,
as we are ourselves! Some of them we render
quite poetic by association with certain flowers
or trees: the magpie is usually painted with
plum-blossom, the peacock with the peony,
sparrows with peach-flowers, swallows with
willows.

Now for the insects! You shudder when
someone speaks of spiders, but we think them
artistic and pleasant enough for our paint-
brush! Besides them we have the butterfly, bee,
and wasp; mantis, grasshopper, cicada, cricket,
and dragon-fly. We have some strange ideas
about them, probably connected with old
superstitions; we say for example, that when a
certain insect is painted on a flower it will evoke
that flower's perfume! It is undoubtedly true,
though, that an insect, which is more fully
'alive' to the human mind than flower or
tree, will help to impart the Life Rhythm to a
picture; you might imagine the painting of a
cicada perched on a soft branch of willows
blown by the breeze; presently the onlooker
would begin to hear the insect's chanting, and
then to feel the wind . . .

Mammals of all kinds are favourite subjects
for our artists, too. We have many masters
who specialised in painting horses, cows or
buffaloes. The horse is appreciated for its

nobility of bearing, its strength and movement;
the others for their association with rural life,
which is deeply rooted in our affection. Lu
T'an-Wei was a well-known horse-painter in
the fifth century, but perhaps the most famous
horse-artist of all was Han Kan of the T'ang
dynasty. The Emperor of his day, Hsüan
Tsung, is said to have had forty thousand
horses in his stable; Han Kan apparently
studied them in every sort of attitude and
presented the finished works to the Emperor to
gratify his sense of possession. Some of the
most common titles were 'Horse-grooming',
'Horse-judging', 'Horse-bathing', 'The Shoeing
of Horses', 'Presentation of Horses', etc.

'Sleeping Dragon' Li, whom we have met in
other connections, was renowned as the greatest
horse-painter of Sung times, while Chao Mêng-
Fu and Ch'ien Shun-Chü were the outstanding
names in the Yüan dynasty. Plate XIX shows
us an example of Chao's work, a horse in the
style known as 'iron-wires'. The outline,
you will notice, is exceedingly thin, yet strong,
like a wire that can be bent but not broken: we
cannot say it is a 'delicate' work for all its
fineness of stroke—the horse seems almost to be
bounding out of the picture in its anxiety to get
at the food. The post is far too slender to
hold back so powerful a charger, the legs of the
animal too thin and short to support our lusty

fellow, 'mais n'importe!'; who would stop to pass so unsympathetic a comment on a painting that is alive?

Not only do we find in the cow a picturesque element of an idyllic pastoral scene, but we respect it for its labour to provide us with food; it is through the cow or ox that our poor people are able to cultivate their rice—we therefore give it a good and respectable place in our art. Typical subjects are numerous—for example, 'Cow returning from the field', 'Cow crossing the stream', 'Cow drinking', 'ploughing', 'fighting', and so on. Next in popularity with our painters are deer, fox, monkey, hare, ram, sheep, cat and dog, as well as tiger and leopard. The dragon is in a somewhat different category, and with its traditional significance and symbolic meaning for our race is often seen depicted with majestic strength and mystic feeling.

We frequently paint fish as well as birds, insects and animals, but not in the manner of Western 'still-life' pictures—lying on a dish or hanging from a shelf in the kitchen. Why should this creature, swimming in its natural element, be any less dignified than a human being? Usually we paint them appearing to swim diagonally across the picture, giving a delightful sense of movement. Having observed fishes at the bottom of very clear pools, many of our artists are able to portray them so vividly

that they appear to be swimming indeed in the most lively possible manner. It is our greatest achievement in this branch of painting that we are able so to impress the onlooker with the fish's movement that we may leave the water itself to suggestion or imagination.

THE ESSENTIALS

THE first element to strike the onlooker in any Chinese painting will always be the action of the 'lines' that built it. 'Line' with us implies 'Form'—it is Form's frontier; that which it contains may be active or inactive, living or not living; everything hangs upon the artist's command of 'line'. Actually the word 'line' in our sense is something more than a mere straight or curved line. Perhaps it had better be called 'stroke' or 'calligraphic stroke'.

Chinese painting and calligraphy sprang from the same source, or rather the former was derived from the latter. First came the pictorial symbol, part writing, part picture; in the course of centuries the two arts have divided widely until the written symbol bears little resemblance to the idea it represents, and painting speaks only the language of inexpressible thought. But in this one respect they meet still on common ground: 'line' or 'stroke' is the basis of each.

The calligraphic strokes are appreciated in proportion to our feeling for Nature. In the process of painting, as of writing, we install this sensuous perception within the composition

of the work, and then in contemplation we express through the strokes an emotional pleasure akin to that of direct contact with natural beauty. Every stroke, every dot, suggests a form of Nature. If not, it would simply be a dead stroke. The colour of the ink, too, helps to make the stroke alive. All these living lines or strokes join together in harmony or in rhythm to form a scene which expresses a definite idea or feeling or thought: then the painting is good.

We ourselves judge our painting from this standpoint; the good painter is he who can play the line-game well. Hsieh Hê, our fifth century art critic, while emphasising 'Rhythmic Vitality' as the first essential of a great work of art, was careful to point out that 'Touch' and command over the 'skeleton' or basic outline were the most important means to this end. A Chinese painter's style depends upon his treatment of lines, and from the style, like the smoke from a Geni's pot, arises that vaporous element—the artist's personality, his 'idea'.

If Treatment rather than Subject-matter is to be the artist's foremost consideration, we shall naturally expect a great variety in it. Some of the strokes I have already described to you: their names are eloquent—'iron-wire', 'willow-leaf', 'bamboo-leaf', 'silk-threads', 'bending-weeds', 'earthworm', 'water-wrinkles', and so

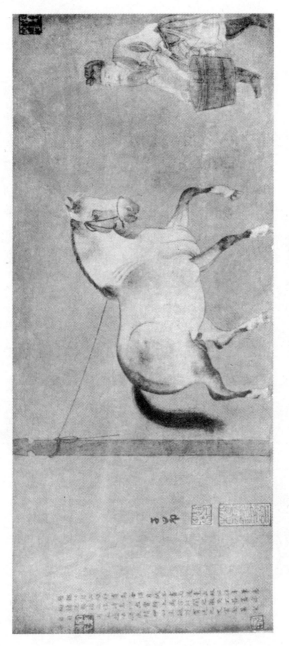

XIX HORSE FEEDING Chao Mêng-Fu (Yüan)

XX LOTUS Ch'ên Tao-Fu (Ming)

on; these are only a handful out of a host. You may be able to pick out from the illustrations some of the types, and remark how well they are in keeping with the subject of the picture, the character of the artist, the general thought of the times. 'Hors de Combat' (Plate IV) uses the 'silk-string', strong but delicate; 'Horse-feeding' (Plate XIX) the 'iron-wire', no thinner or thicker perhaps than the 'silk-string'; but just as you can distinguish in actuality between wire and silk, so you may feel the different strength of these two stokes.

You may well imagine that such fine discrimination calls for both concentration and technical mastery; our artist, before he takes up the brush, must have a clear vision in his mind of that which he is to transfer to paper; any lack of positive conception is only too obvious in the character of his strokes—and hesitation condemns not only the artist but the man! The poet Tu Fu was a wise observer when he remarked that 'It takes ten days to paint a rock and five days to paint a stream'; he was thinking not of the time spent on technical labour, but of the long hours of inward meditation while the whole painting took shape in the mind. When an artist's idea is complete, and only then, he will pick up his brush and give form to it in sure and rapid, though never careless

strokes: he will have learned from continued practice to be the master of his instruments and not their slave. As you know, we do not paint on canvas or wooden board, so that our stroke, while being a firm one, must also be a light one. To this end, we do not hold the brush between thumb and forefinger, but upright and suspended between thumb and two middle fingers. In bold work the movement of the whole arm is brought into play; in delicate work that of the fingers only; but however fine the painting, our artist's aim is to bring the powerful strength of his whole arm down through the handle to the narrow tip of the brush and thence on to the surface of the paper. In its contact, the touch may be rough or delicate, heavy or light, quick or slow, oblique or regular, curved or straight, but it must, above all things, be sure.

The general historical tendency in treatment of Line shows a movement towards increasing looseness and freedom: the T'ang and Sung artists had an exceedingly careful touch—each stroke seemed to have a conscious certainty of direction from tip to tip. Many of the painters followed closely the traditional rendering of 'line' from Ku K'ai-Chih downwards. A work by 'Old-Lotus' Chen, a Ming artist (Plate VI), illustrates the point very well. This traditional 'line', known as 'Shuang-kou' or 'double-line',

came from the earliest development of calli-
graphy, in which each line had an even thick-
ness. It is largely employed for the contour
line of the subject depicted in a delicate piece
of work. The fine, mobile lines of the drapery
in Botticelli's famous 'Primavera' resemble it.
The 'boneless' style of brush-work was devised
when the calligraphic strokes had been further
developed to express the feeling for varied
living things in Nature. The lines or strokes
are not of uniform thickness and are shaped
more like forms than single lines. Notice parti-
cularly Ch'ên Tao-Fu's painting of a lotus
(Plate XX); he chooses mainly the 'without
bones' treatment. How remarkable is the dis-
position of ink-shading, the beautifully gradu-
ated arrangement of light and dark, its fluency,
its rhythmic balance!

I have been looking over and over again at
the works of Cézanne, Gauguin, Matisse, Van
Dongen, Marquet, and, especially perhaps,
Van Gogh. Without exception, I think, these
artists have concentrated upon simplified form
and a mastery of line. As far back as 1912
the English art critic and painter, Roger Fry,
wrote of Matisse:

'He aims at convincing us of the reality of
his forms by the continuity and flow of his
rhythmic line, by the logic of his space rela-
tions, and, above all, by an entirely new use of

colour. In this, as in his markedly rhythmic design, he approaches more than any other European to the ideals of Chinese art.'[1]

Some of the line-work of Matisse is quite like the Chinese 'silk-strings' and his trees like a modern Chinese willow surprisingly transplanted to a foreign soil. Gauguin's use of line contour is the most obvious of them all; the stiff and powerful strokes running from hip to toe of his figures may be compared with the Sung treatment, but one must admit that it is rather to the art of India than of China that he has turned. This new element in Western art, extracted from the East, seems to have brought your artists a draught of refreshment in a season of drought.

The second important landmark of which I should like to remind you is the independence of natural things in Chinese painting. Among the ancient masterpieces of the West I have found very few examples of 'Still-life'; until quite recent times the human figure seems to have been the painter's Helicon as well as the basis of his draughtsmanship and composition. Cézanne, however, and some of the younger artists who followed his methods, began to paint apples and old chairs, sunflowers, loaves

[1] Preface to Catalogue of second Post-impressionist Exhibition, Grafton Galleries, 1912, reprinted in 'Vision and Design,' 1920.

of bread, pots, and fishes, with an independent life; Nature is no longer a supplement to Man —she has abundant life of her own, and even an inanimate object has significance, attitude, personality, for the painter.

Our brush and ink, as I have told you, do not respect man's affairs, and these artificial arrangements of objects, these plants stuck in vases smell altogether too much of the human hand: we do not forget Ta-Mo and the 'Four Books' of the Classics; our artist might well contend that Van Gogh's old chair with its scissors lying across it had 'a certain quarrelsome smell' about it (p. 81). We do not like to paint that which is devoid of life and motion, but we have the greatest sympathy with those elements of the universe which are patient and lasting: man, whose movements are often no more dignified than those of the dancing bear, and who rushes blindly here and there picking up the dust of the world on his feet, seems of less worth to us than the living rock which endures storm, the lotus which rises in white purity from mud-heaps, the crows who fly faithfully back to their nests at dusk. By continual observance and by projecting ourselves into the life of Nature, we are able to present the feelings of natural things without a human connection: a chrysanthemum, a pine, an orchid may each stand alone in a picture; if

human figures are added to a scene the scenery itself has its life independent of them. A glance through the illustrations of this book will provide sufficient grounds for my hypothesis: look at Pien's wild geese (Plate XXII), Ch'ên's lotus (Plate XX), Yen T'ung-K'o's 'Birds returning through a snowy sky' (Plate XXIII). This last example witnesses the most vivid possible presentation of natural life: everyone knows that these are quarrelsome, talkative birds, and that their harsh crying is heard especially when they congregate together at sunset, returning home. From the attitude of those near the trees we can see clearly that a clamour is going on; we see also that there is an opposing wind blowing in the face of the returning wanderers: those in the background seem to be sweeping and wheeling, trying by some means to reach haven; one only in the extreme centre appears to have been victorious and sails in, wings outspread, triumphant. This, rather than the duck hanging dead from the poulterer's hook, is, for us, the life of Nature in paint.

Simplification of Form is another important element in our painting. Our artists have claimed the right to simplify, to extract the essentials from appearances, since the very root-beginnings. The forefathers of Chinese art had worked out simplified forms of natural

objects in our ancient scripts. Our artists
practise them and give life to them as well as
create new simplifications continuously. They
must not only indicate the form, but must
preserve the life and spirit of an object. The
choice and construction of the simplified form
requires, of course, good taste, and good taste
has to be cultivated. This is done by con-
tinually observing beautiful forms in nature
and studying them in the existing arts. When
our artist examines a subject, he first picks out
the barest, simplest aspect of the form, analyses
it, and, while preserving carefully the relation-
ship of its parts, tries to give expression only to
those elements which contain the spirit, the
essence, the 'atmosphere' of the object. This
ideal, applied from the beginning to form—
notice, for instance, the almost primitive sim-
plicity of the Pavilions in Wang Wei's picture
(Plate VIII)—has more and more affected
treatment as well: strokes grow fewer and
simpler, one may almost say more abstract;
perhaps our art approaches a new childhood!
Notice, for example, Kung Hsien's landscape
entitled 'Peace, perfect peace' (Plate XVII)
with its simplified treatment of tree and rock;
we could never see a tree like this in actuality,
but neither could we deny its 'treefulness' in
paint. Kung Hsien has presented the idea of
'tree' with far more power than any realistic

painter who tries to imitate leaf by leaf and to mix his greens for catching each tint 'to the life'.

We simplify human as well as natural forms; the effect may be a little difficult to appreciate for the unaccustomed eye. For instance, we will paint the nose of a lady with one curved line rather like the English capital L, neglecting all complicated considerations of light and shade: it may not exactly resemble the original nose, but we think it will be enough to express the conception, 'Nose'. Similarly we can indicate an expression of sorrow by simply painting one or two thin lines between the eyebrows, laughter by a few lines at the corner of the eyes curved upwards, old age by a single vertical line on each cheek. At a first acquaintance this type of treatment may seem crude, but we are of opinion that the artist can better express his own thought thereby than through a meticulous imitation of actual forms; he can show us just those elements which struck him as the essential ones, whether of a formal or an emotional nature.

Closely connected with Simplification is a fourth outstanding element of Chinese painting which lies somewhere between the Grotesque and the Exaggerated. You will find peculiar scenery with mountains piled on top of one another, a few sprays of bamboo or orchid leaf

suspended from nowhere, a very ancient sage with a head one foot long and a two-foot long body; China, you may think, is indeed a strange part of the world, fit only for colour-blind artists and mad poets with their heads full of nonsense.

'Their heads are green and their hands are blue
And they went to sea in a sieve,'

sang your poet Edward Lear, about certain people called 'the Jumblies'.

But our painter is not really mad; he merely wants to appropriate Form for the time being to his own ends: the piled-up mountains are his dream-country, composed of familiar constituents, but in a different order; his emphasis, his exaggeration are parts of an individual vision. The Sage's foot-long head has a spiritual connotation, like Confucius' bulky forehead (Plate I). After familiarity this element even becomes a beauty, and now it begins to find acceptance with the most 'advanced' artists of the West.

Finally, I must add a word about 'Rhythmic Vitality'—the most vital part of all in our paintings. Hsieh Hê told us it should be the sole aim of painters and that it was the sum of the other five 'principles of painting', but he left no explanation. Liu Hai-Su, after defining

the Chinese expression 'Ch'i-Yün Shêng-Tung' as the combination of two ideas—'Rhythmic harmony—Life's motion', interprets the whole meaning as follows:

'The word "Ch'i" in the phrase "Rhythmic harmony" or "Spirit harmony" is in fact scarcely to be expressed by anything but spiritual sublimity, the nobility of man's nature, the depth of his feeling. The second word "Yün" expresses musical rhythm and the influence it leaves upon the soul. ("The spirit sets in motion the phenomena of the world as the hand of the harp-player sets in motion the strings of the instrument.") "Life's motion" (Shêng-Tung) is life, in the aspect of its manifestation of movement. . . . Actually this "rhythmic harmony" is found everywhere where there is life. Only if the painter is under the influence of an interior emotion will he express, through the medium of his brush and Chinese ink, this vital animation. . . . It will be readily understood that in most cases Chinese painting expresses the inward expansion in a man of that vitality, that mobility which is Nature's, and which identifies itself, for him, with his own feelings.'[1]

Before he takes up the paint brush, our artist must feel his heart beating beside

[1] Catalogue to the Exhibition of Modern Chinese Painting, New Burlington Galleries, 1935.

Nature's, must be conscious of sharing in her creative acts; this is the only way to the making of a masterpiece. Kuo Hsi, one of the greatest landscape painters of the Sung dynasty, and a critic of some authority, wrote once:

'Before beginning to paint, a man should feed his inspiration. He may drink in the cloudy spring weather, or watch the forms of flowers and birds, stroll about reciting poetry, or burn incense and taste tea. As soon as the mind feels the approach of inspiration the hand instinctively has an urge to paint; then he may open out the paper and prepare the brush to give it expression: when inspiration dwindles, let the brush stop and continue at the next inspired moment. The result will then be of unusual excellence and full of "Rhythmic Vitality".'

From this we may see that the achievement of a masterpiece does not merely depend upon identifying one's feeling with Nature, but upon a spontaneous creative act.

Our painters have no preconceived conception of natural form; they are ready to create anew with every fresh presentation; they try to find the true feeling of each natural thing distinct from its superficial appearance. That may well be another source of the grotesque or exaggerated in our art; we try to find, feel, touch the original condition of some beautiful

thing, as it may once or never have been on earth. 'Rhythmic Vitality' is not an aspect of the world that presents itself openly to the passing eye—it is a view of life which may be possessed by the painter in certain moods: if his brush is able to capture the vision, then accurate form, light and shade, logical proportion, realistic colouring and all other considerations of this sort become relatively unimportant. We believe that 'Rhythmic Vitality' is impersonal and existing in its own state; it cannot be achieved through pressure or artificial force—that which is itself natural and vital. If the painter is able to seize the basic form and the inmost spirit of a natural object and give it free expression without the domination of artificial ideas, he will have made one more contribution to the embodiment of the Life Force. And so he does not paint at all times, nor can he be compelled to paint, nor can he be tried at the Bar for neglecting the obvious truth of appearances; 'Rhythmic Vitality' is the judge of appearances; if an object is possessed of this quality it has the 'right' form, otherwise we should be unaware that it was 'alive'. 'Life' is the concomitant of 'Rhythmic Vitality'; if a picture lacks this element, though it be as close an imitation of visible form as a photograph we must still deny it life. We have the term 'Chuan

Shen' or 'Transmission of Spirit,' as I told you, in place of 'Figure-painting' or 'Portraiture'; we have also 'Hsieh Sheng' or 'Writing Life' for the painting of a flower, bird or animal, and 'Liu Ying' or 'Leaving a Shadow' for landscape: all three expressions contain the meaning of 'Rhythmic Vitality'.

Composition, Hsieh Hê pointed out, besides Essential Structure and Touch, is an important contributor to this chief aim of the artist: whether it be a tree-branch, a spray of flowers, a bird or a human figure, every object should have its carefully selected position on the paper; if there are several components the artist should be clear about their relationships, and see that deference is paid to rank. In a landscape we speak of 'first finding the positions for Host and Guests'; let the largest mountain first draw the eye, let near objects stand out more vividly than distant ones; let anything which does not contribute to the painter's thought be summarily removed: better far a blank space than a superfluous detail.

Indeed the use of space is one of the Chinese painter's most coveted secrets, one of the first thoughts in his head when he begins to plan his composition. Almost every space in our pictures has a significance: the onlooker may fill them up with his own imagined scenery or

with feeling merely. There was a Chinese poet of the Sung dynasty, Yeh Ch'ing Ch'ên, who wrote the sorrows of a parting and described the scene as follows:

'Of the three parts Spring scene, two are sadness,
And other part is nothing but wind and rain.'[1]

Who would venture to paint this scenery, but yet who would deny the truth of it? This is what we leave to the well-disposed blank, more eloquent than pictorial expression. The disposition of it, however, calls for a high degree of judgment: if it is too narrow and confined the onlooker will feel as if he were drawing breath with difficulty in a small airless room; if the spaces are too long and the concrete forms too loosely separated, he will feel that all air has escaped from the world and that he must die soon. We know that the organs of a human body must be in certain positions and have a certain size in relation to each other or the person is not able to live; so it is with a picture—there must be a balance of Composition, a relationship and harmony of forms, a link between that which has volume and that which has imagined shape only, or the 'Rhythmic Vitality' which is the only test of artistic life, will never make itself felt.

Finally there are six faults which our artists

[1] Translated by S. I. Hsiung.

must try to avoid. There must be (1) no trace
or smell of vulgarity—no resemblance, for in-
stance, to a village girl trying to paint her face
for the first time; (2) no suggestion of the
artisan, who can only display technical skill,
without conveying the spirit of the object;
(3) no trace of temper to destroy the peace of
a work; (4) no coyness; (5) no humbug to
cloak a fake; and (6) no taint of commerce or
'trace of copper' (no smell of banknotes or
cheques would be the modern equivalent), by
which is meant painting with an eye to
profit.

THE INSTRUMENTS

In the foregoing chapters I have tried to explain some of the general ideas inherent in our painting; now we must turn to the media and instruments. The evolution of our art is more intimately related to the nature of these instruments that we use, than in most other countries: even in modern times we choose subjects with an eye to the special qualities of our media, loving to paint the pine, bamboo, and willow, not because they are the only trees in China, or even for their symbolism entirely, though that is a point for consideration, but because their outline and components are ideally suited to our brush and ink.

Before the days of painting in China, when primitive symbols were apparently the only form of self-expression, the writings were cut in wood, then later, on stone, bronze and the bones and shells of animals. The implement used was a knife made from a kind of metal. The character which is equivalent to your 'pen' has the primitive meaning, 'an instrument for making images', and this primitive engraving

knife is called the 'iron-instrument-for-making images' or the 'iron pen'.

A little later the characteristic Chinese varnish was discovered, and was used for describing simple designs on banners and for painting primitive frescoes. The instrument for applying it was called a 'varnish pen', the same 'pen' character as for the ancient knife and the modern brush. The development is apparent.

Confucius, sage of the Chou dynasty, had a sheet of thin bamboo, shaped rather like a plate, upon which he wrote. It was a personal and manageable surface at least. From this there developed cloth and silk for writing and painting, and eventually paper. Our instruments, from rough beginnings, following necessity, reached at length the highest degree of delicacy and fineness.

We have a special term for Brush, Ink, Inkstone, and Paper; we call them 'The Four Treasures of the Room of Literature.' They are all four indispensable to the painter and the scholar, and so the men of letters have named them 'treasures'. I will give a separate account of each:

1. *Brush.*—From historical records we learn that the General Mêng T'ien, of Ch'in dynasty, was the first to make a painting brush. His invention is described as having a handle made

from a kind of wood, and a tip of deer's hair inside a fringe of fine sheep's wool. But from other evidence we must believe that brushes were in existence before the Ch'in dynasty. There is a story about the famous Duke of Chou that he painted a tortoise with some kind of brush instrument; Confucius too is credited with possessing one. The reason why we have no authentic record of their manufacture in these early days may be due to the disastrous work of the first Emperor of Ch'in in his burning of ancient documents.

From the Han dynasty onwards the ground is surer; we even have knowledge of the different materials used. At that time the art of calligraphy sprang suddenly into popularity; some new styles of character writing were evolved, particularly that which we call 'Tablet'. The educated people were eager to practise, and large quantities of brushes seem to have been produced with increasing delicacy of workmanship. In most districts rabbits' hair was chosen, though we are told that the painter Chang Chih made one from mouse-whiskers. Apparently the kingdom of Chao produced particularly good rabbits, fit to furnish hair for the royal brushes. The handles of these were sometimes made of gold —beautiful things to possess indeed! Later, in the Chin dynasty, ordinary handles were of

quartz, horn or ivory, not infrequently orna-
mented with rich engravings.

Even the rabbits of Chao did not satisfy
Hsiao Tzu-Yün, brush-maker in the 'Six
Dynasties' period; he formed the core of his
brushes from human babies' hair! Each suc-
cessive dynasty tried to refine upon the products
of its predecessors, though rabbit hair remained
the most popular choice. Ou-Yang T'ung of
the T'ang dynasty made the centre of fox hair
with rabbit for a surround, while another
maker, Chêng Kuang-Wên, combined fox and
deer only, making rather a stiff variety; we
have given it the name of 'Hen's claws' be-
cause of its rigid texture. All these varieties of
hair gave fairly short tips, and the T'ang calli-
graphist, Liu Kung-Ch'üan, finding them un-
suitable for his style of writing, set out to dis-
cover a longer type of animal hair convenient
to his purpose. Eventually he produced the
sheep's hair brush, and this became popular
immediately for the longer, softer type. Two
other famous calligraphists of the Sung period,
Su Tung-P'o and Huang Shan-Ku, liked using
brushes of mouse-whisker with a covering of
sheep's hair; they were made by a great brush-
manufacturing family—Chu-Kê, of Szuchuan
Province. The special place for rabbits in the
T'ang dynasty was Hsüan-Ch'êng in Anhui
Province; there the rabbits were said to be

sleek and furry, with long hair, neither too pliant nor too stiff. All the while, makers were becoming more skilled in the handle work; by this time our brushes were real objects of art.

And so the process went on—sheep, deer, fox, wolf, mouse, or rabbit, according to the idiosyncrasies of individual calligraphists, or the requirements of a particular style of writing or painting. All these different kinds are used in the manufacture of instruments to-day, though the handles on the whole are of simpler, less costly materials than the precious metals of the ancient emperors. Commonly they are of bamboo or the stem of a kind of weed, with a small mounting of gold, silver, jade, ivory, or crystal at the tip.

The making of brushes calls for extreme delicacy of handling. I will give you a brief description of the manufacture of the rabbit's hair variety. In spring and summer, when the rabbit is getting new growth, the hair is too soft to be satisfactory; in winter the fur is in poor condition and moulting; we use it therefore in autumn when it is neither too soft nor too thick. We take good care of the animals —that they have plenty of food, for then their coats grow long and furnish us with fine-pointed brushes. We pluck usually from the middle of the back or flank, selecting with the utmost care and dipping in lime-water, slightly

warmed, to dissolve any oil. We then tie up the hairs in little bunches for mounting in handles, the thickness varying according to the type of writing or painting for which the brush is to be used. The process, as you see, is not complicated, but it calls for sharp eyes and neat fingers.

For delicate painting, wolf and rabbit are generally chosen, sheep for bold work. The sheep's hair brush admits of free and flowing strokes and we prefer it, on the whole, above all others for landscapes; better than any, it can describe the lines of a rushing torrent and the sweeping curves of a mountain-side. Sometimes we take up a very old brush for this type of painting, with a worn, blunt point; we find it ideal for outlining jagged rocks or rough, tumbling water.

Every painter ought to possess his own brushes and train them in his ways like a servant; gradually they will take on a trace of his own personality and genius. In the past many of our well-known artists would not trust to the skill or judgment of craftsmen for such a valuable aid to their creative life; they made their brushes themselves.

2. *Ink.*–Our Chinese ink is not made in the liquid form with which you are familiar in the West; it is condensed into a solid block which is ground on the ink-stone with a little water

just before use. We cannot be certain, of course, whether this was the primitive method of manufacture, but we have specimens of these ink-sticks many hundreds of years old.

We may assume that ink in some form was in existence in China before the invention of the hair brush; already in the Chou dynasty there were paintings on banners, royal furniture, and gateways, and these were merely black outlines of various images—an authentic proof of the existence of ink at a time when we are very doubtful about the use of brushes for painting. Historical records actually tell us that an Imperial Registrar of early Chou dynasty compounded some ink for writing upon cloth, while in pre-Han days, in the time of the 'Warring Kingdoms', it was certainly used for dyes.

During the Han dynasty, graphite and pine-smoke were apparently the two media for ink-making; the graphite, a kind of soft stone, was ground to a juice, making a very good, dark-black fluid. But it is the pine-smoke variety which has survived. It is made by collecting the deposit left by the smoke after contact with some plain surface and mixing it with a gum. In some districts we have special pine trees which emit particularly black smoke when burned. Moreover, we are so attached to the scenery of our country, that, knowing the pines of a loved and familiar mountain have

helped to make our ink-stick, we treasure it the more for that. Each dynasty thought to find pines of a rarer blacker smoke than its predecessors: the Han makers went to the mountain of Fu Fêng, the Ch'in to Lu Shan—the beautiful mountain of Kiukiang. They thought too to improve upon the simple ingredients of smoke and gum: a certain Li T'ing-Kuei of the 'Five Dynasties' period supplied all the leading calligraphists with ink-sticks, and he compounded them from ten parts of pine-smoke to three of powdered jade and one of gum. The Sung dynasty apparently found the secret of a very deep black variety; they made it from the deposits of both burnt pine and burnt oil, mixing either with deer-gum and a little perfume. If you examine Sung paintings carefully you will be sure to notice the particularly dark colour of their ink, quite different from the tint of present-day varieties. Clearly this question of ink colourings will be important in the dating of works of art.

This second 'treasure of the room of literature' is as much an object of thoughtful care to the painter as his brushes; at the time of the Emperor Ch'ien Lung of the Ch'ing dynasty some famous painters by name Chin Tung-Hsin, Ch'ên Man-Shêng, and Huang Hsiao-Sung had their own apparatus for making the sticks, determined that even the means for

transferring Nature and the creative Idea on to the painting scroll should be in their own hands. In this same period, 1736-1794, the ink was made into blocks of varied sizes and shape, sometimes heavily ornamented with detailed carvings. It is not surprising that some art lovers have made collections of both ink and brushes, so elegant and ingenious are their forms. There was once a gentleman named Chou Li-Yüan who amassed ten thousand specimens of ink-sticks; it is said that every New Year he would range them out in his studio, drink wine to them, then kneel down to worship them—so deep was his love and veneration! In China we do not think that strange.

Nowadays the process is much the same for the manufacture of ink as in old times; we have kept to traditional recipes. The proportions are ten parts of smoke-deposit to five of best quality gum. After mixing and shaping, the sticks are put into a warm place to set; should they be exposed to too much heat the odour is offensive, while too intense a cold prevents their solidifying.

We like to keep our sticks many years before using them; we let them mature like old wine, sometimes as long as fifty years. By then they have gained more than an element of dura-bility—a kind of venerableness as well, giving

dignity to our strokes. You will find that the Chinese artist does not thirst for novelty, either in subject or atmosphere; rather his brush seeks to convey an atmosphere of mellowness and age.

Our choice of ink depends upon the nature of a painting; the pine-smoke variety makes a deep black liquid with a dull finish, and we use it for the dark shadows under mountain wrinkles, and for pine foliage. Oil-smoke ink is not so black and gives a rather bright, glossy surface, particularly suited to trees or rainy and windy scenery. The best ink manufacturers from early Ch'ing times until now are Hu K'ai-Wen of Anhui and T'sao So-Kung of Chekiang, whose ink-sticks are widely used all over China.

3. *Ink-Stone.*—This is in essence a flat stone upon which to grind and mix the ink, one end being slightly scooped out to contain the water. I suppose this 'Treasure' is something quite unfamiliar to the West.

Archæologists cannot find any records of its early use, though a certain writer, Wu Ch'i-Chih, remarks in one of his essays that he has seen an ink-stone in the temple of Confucius in Shantung. The style and type are of great antiquity, he adds, and confidently claims them as the genuine property of the Sage during his lifetime. Wu may be right, for one can be sure

that Confucius was a resourceful scholar; but we have no proof of it.

Our earliest authentic examples date from the Han period; besides the now familiar stone variety, some of these are made of iron, and even jade. In the Chin dynasty the makers conceived some very graceful shapes for the stones, giving them the name of 'Phœnix-Character' or 'Wind-Character', after our written symbol for these two words.[1]

Bricks and roof-tiles have also been utilised for ink-stones; the Han brick-makers were particularly successful in compounding bricks of harmonious colour and shape; later generations were eager to use them for a Study Treasure. Here again you will notice our love of antiquity: we hold the opinion that a new brick fresh from the oven lacks not only value, but beauty and character; we say that a 'fiery atmosphere' lingers about it still. After many years it forgets the fire, becomes quiet, cool, mature, fit for use by artists and men of taste, a suitable companion for the mellowed ink-stick and finely-formed brush.

All through the Chin dynasty these brick and tile ink-stones were very popular; many were made from the tiles of Bronze-Bird

[1] The outlines of the Chinese Characters for Phœnix and Wind are similar, and very much resemble the shape of a Greek lyre.

Terrace, built in Wei times by T'sao T'sao. In colour they were bluish-black, and in texture very finely compounded, and with some engravings upon them or an inscription in 'Official style' characters. This is a type very much coveted by collectors.

In the T'ang period, when every form of culture was refined to the utmost, ink-stones of extreme beauty were produced; some of pottery in the 'Wind Character' shape, others of stones veined and coloured, coming from special districts of the empire. From Tuan-Hsi in Kuangtung came blue-black, mauve, and deep red like a sheep's liver, while the province of Shantung produced some very lovely ones with red veining; the great T'ang calligraphist, Liu Kung-Ch'üan, liked these particularly, for he said they were less porous than pottery, and kept his ink from drying up. The T'ang poet, Li Po, lover of wine and beauty, had his own type of ink-stone—pottery covered over with enamel; a great prize to collectors also!

The Imperial House of T'ang was a firm patron of the arts and many of the Emperors liked to paint or write poetry. As ink-stone construction became something of an art itself, nothing would satisfy the Emperor Hsüan Tsung but he must have his own stone in the royal buildings and make ink-stones to his own design. He made them in the shape of a

crescent, of a special stone, rough-surfaced as if with scales, and called them by the name of 'Dragon-scale-moon-crescent.' Each Prime Minister in turn was presented with one, and we may suppose the Emperor thereby symbolised his desire for the Kingdom to be governed by art and scholarship, as much as by official edicts.

Hsüan Tsung appears to have set a precedent; during the 'Five Dynasties' period the Emperors appointed special officers for making the stones: Li Shao-Wei, of Anhui Province designed his specially to suit the fastidious tastes of Emperor, Painter and Calligraphist. His are known by their shape as 'Dragon-tail' ink-stones.

The Sung dynasty added to the range of colours by discovering some stones in Hupeh province of a beautiful dull-green shade, and others in Szuchuan entirely black, both excellent for the purpose, while the Ming dynasty makers returned to the tile variety, using roof-tiles from Infinite Happiness Palace, an ancient building of great glory in Kiangsi. Under the Ch'ing, ink-stones were particularly noted for their artistic shape and design; they were decorated and engraved, shaped now like a peach, now a lotus flower, now a deer or a fish. People began to collect them as they would valuable pictures; even quartz and jade

were used to make pieces more exquisite still. The ink-stones of the Emperor Ch'ien Lung of this dynasty have never been surpassed for elegance, taste, and splendour of workmanship.

Collectors love this 'Treasure' from different points of view—some for the colour of the stone itself, some for its design, some for the interest of the inscriptions; others will treat the stones as antiques and value them archæologically, while there are many more who will take a practical pleasure in them and appreciate those which grind their ink the best.

A man should care for his ink-stone as an object capable of feeling and response; he should wash it clean daily after use, for stale ink does not have a true colour. Sometimes, however, we need to paint with stale ink, to get some effect unattainable with freshly-made ink, but in this case one should add water continually to keep the ink from drying on the stone and staining the surface. In very cold weather we put away our best ink-stones, for they are brittle and sensitive, liable to break if the atmosphere is frosty.

From the artist's own point of view, it is best always to make fresh ink, immediately before use; if it is left on the stone, especially during our hot Chinese spring and summer, the gum will be affected, and the ink flow harshly and unevenly over the paper.

4. *Paper*.–The characteristic Chinese paper is coarse in weave and more porous than that with which you are familiar in the West; it is specially suited to our manner of handling the brush—rapid and lively, with balanced alternation of light and dark strokes. The composition of any Chinese character will illustrate my meaning. But before the modern type of paper came into use, many and strange varieties of material were employed by the artist. A kind of silk appears to have preceded any sort of paper, and then a bamboo tablet. Eventually, under the Han, in the reign of the Emperor Hê, an official of high rank, T'sai Lun, made a paper of tree-bark and hemp. His invention brought him lasting fame, for it received the name of 'The Duke of T'sai Paper', and was immediately popular in the place of older materials. Rapidly other variations sprang up; there were already a red paper, a yellowish paper, and a hemp paper before the dynasty came to a close.

In Chin days the imagination and inventiveness of paper-manufacturers were unbounded; Chang Hua made one variety from water fungus; another made a yellow-coloured paper like fish-eggs, another like silkworms, and yet another produced a kind known as 'cloth-paper' from the cloth-like appearance of its surface.

In the 'Six Dynasties' period, the Emperor Kao of Ch'i appointed a special 'Paper Official' to superintend paper manufacture. At this time it often had a shining, glazed surface. Under the T'ang, paper-makers had to keep pace with the enormous output and variety of art; some sheets were as much as six feet in length, and three or four feet wide. The more ordinary kinds were the 'Black Hemp' and 'White Hemp', but there were others of poetic name and dreamlike substance. 'Blue-Cloud' paper had a colour like a blue sky in mist, while the 'White-Jade' had a surface as elegantly smooth as its name denotes. Some of the poets invented their own varieties and perpetuated them under their own names. The famous poetess, Hsüeh T'ao, was one of these.

During the 'Five Dynasties' period Prince Li Yü of the Southern T'ang Household commanded a special paper to be produced for the use of great writers and painters only. It was yellowish like the older 'fish-egg' variety, but as strong and pure-coloured as if it were a sheet of jade, very thin and exquisitely smooth. It had the name of 'Purify Heart Hall' paper, after the Hall of the Palace where the literary men used to congregate. It was admired and wondered at by all: the people of Sung treasured it like a precious thing.

The Sung emperors also superintended the making of a special paper; it was longer than ever—about twenty by ten feet, rather thick and strong, with a good painting surface. At the same time there were some more delicately designed makes with a shining surface, woven rather like cloth material, and with a faint tracing of flower, tree, insect, or fish upon them. In Fukien province they would wash the paper in a solution of gum and then press it, to make a fine, close texture. In Hopei they used the bark of a mulberry tree, and in the Southern reaches of the Yangtze, where bamboo grows plentifully, bamboo paper was manufactured in quantities. The painters Su Tung-P'o and Mi Fei admired this kind particularly. A little later, in the Yüan dynasty, they made a very lovely paper in Kiangsi which was named 'Goddess of Mercy'. In Ming they had yet another variety — 'Weaver-of-bamboo-blind' paper.

By Ch'ing times men were familiar with every possible material for paper-making, and it only remained to perfect the process. The materials chosen in the different districts were really dependent upon the provisions of Nature: in Szuchuan hemp grew abundantly, so that the hempen variety was chiefly produced in that province; Chekiang, Kiangsu and Kiangsi are rich in bamboo groves, and the characteristic

XXI AN EAGLE Pa-Ta Shan-Jên (Ch'ing)

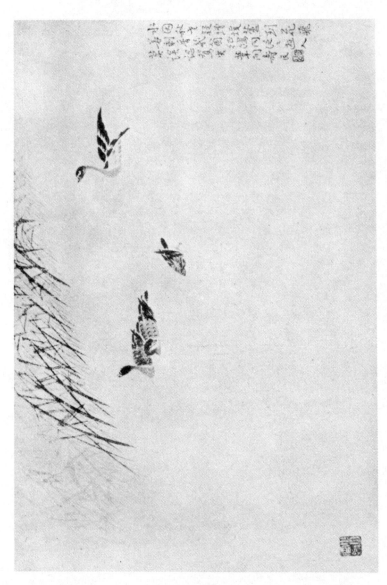

XXII WILD GEESE Pien Shou-Min (Ch'ing)

paper of those parts was of bamboo; North China used mulberry tree bark for the same reason, and sea-coast towns the water-fungus.

We divide all these types into two, according to the process of manufacture; the 'ripened', which is dipped in warm solution as I explained above, and pressed to give an added fineness to the texture, and the 'unripened', which is ready for use immediately after the initial process. The first kind is less porous after its gum dressing and is very well suited to delicate painting and calligraphy, where the brush moves slowly, and the Idea is built up from an assembly of hair-fine strokes. The unripened is best for bold work, and goes well with the sheep's hair brush. It is almost as loose and absorbent as blotting-paper—splendid for land-scapes on the large scale, for it lets the water flow freely, and responds to the broad, power-ful, energetic touches of the painter.

As I have said, silk probably preceded paper as a painting medium; from the records we are told that the wife of the Yellow Emperor, before the Golden Age of Yao and Shun, had already found the secret of silk-making and was teach-ing it to the people. But silk paintings did not cease with the discovery of paper; some painters still prefer it to the present day. The first calligraphist, to our knowledge, to choose it for a writing surface was T'sai Yung of the

Han dynasty. He was apparently a fastidious gentleman, very proud and particular about his artistic work. Paintings on silk have existed since the Chin dynasty: discoveries made at Tun-Huang have brought to light hanging paintings of this material.

As with paper, there are treated and untreated kinds: the early T'ang painter Wu Tao Tzŭ and some of his companions put their silk into boiling water to shrink it, finding that it took the paint better that way. Texture and size are both important guides to the dating of silk paintings. For instance, the 'Five Dynasties' silk was extremely coarse, almost like linen, while that of Sung was both thick and thin but of a very fine weave. Coloured flower and bird paintings are the most characteristic product of this era, and the fine silk was a particularly happy instrument for that type. In Yüan times, a Mr. Pi invented a weaving machine which could produce silk almost as pure and fine as that of the Sung craftsmen.

Chinese paintings, either on paper or silk, are always mounted (not framed) on vertical or horizontal scrolls. The vertical scroll can have a height of 60 to 80 inches with a width of 40 inches or more, while the horizontal one may have a length of perhaps 200 inches with a height of 30 inches or less. It is generally in the large-sized paintings, either vertical or

horizontal, that Chinese masters have revealed their soul and make their thought and moods flow as smoothly and swiftly as the running water of a river which knows no end. Unfortunately paper and silk are the more perishable because they are not framed and protected by glass. On the other hand, to mount pictures on scrolls has great advantages. A large number of works can be collected, which when rolled up require very little storage space. The Chinese connoisseur prefers to look at works of art one at a time. He does not cover the walls of his house with his collection, but hangs one or two pictures in chosen places, and when he has studied and appreciated them thoroughly, changes them for others according to his mood. The long horizontal scroll will be slowly unrolled on a table for inspection, or appreciation rather, inch by inch and foot by foot. In this way he avoids confusion and enjoys the work thoroughly.

I must say a word about the coloured background of a finished picture. After a painting is completed, it is hung up for a period. With time, in the dry climate of China, the colour of paper or silk will turn yellowish or slightly brown. The air of antiquity which results from its exposure and discolouring is something that we admire. But the collector should beware! Foreigners not thoroughly acquainted with our

customs may be led astray. If a great master-piece comes into our hands, we keep it care-fully, not exposing it to the light for long at a time, and so it may appear much less 'antique' than others which are several hundreds of years younger but 'doctored' with colouring medi-cines by the crafty dealer!

THE SPECIES OF PAINTING

As a tree grows very aged, it tends to divide into a multiplicity of branches, each pushing its way into life from a different direction. So it is with the development of our painting; I want to give you some idea only of the general formation of various shoots.

1. *Painting and Stone-carving.*–In an earlier chapter I have pointed out how our early picture-writing, engraved first on wood or bone, and subsequently on bronze and stone, was a form of drawing, and not a mere symbol for ideas made up of lines and curves: it gave an intelligible representation of a visible object, such as an elephant, a deer, a cow, and so on. Before these engravings were made, the outline must have been sketched out on the stone; the instrument may have been knife rather than brush, but one must admit that the rudiments of painting were already in existence at that time, for 'painting' in China implies outline rather than colour.

The art of the Han dynasty was chiefly in the form of stone-engravings, many of them human figures or stories of ordinary life, illuminating

for our study of social backgrounds in those far-off times. We are to presume that many of them were monuments from the family ancestral temples or even tombstones, the engraving serving the purpose of decoration. There were also stone-carvings round the walls of temples—the ancestor of the Fresco; the best-known ones belong to Wu-Liang Temple in the Province of Shantung. They are all figure-carvings of a non-religious nature, and have the margins of each group engraved with flowers and birds; the carvings have a volume and solidity bearing some relationship to sculpture. In general effect one might perhaps compare them with the mediæval wood-carvings of European churches, where plants, birds, and animals of every sort decorate the borders of biblical scenes; scenes that, for all their religious character, contrive to taste very much of the world of the Middle Ages.

During the period of religious fervour, in the Wei, Chin and T'ang dynasties, when religious painting was especially prolific, portraits of Buddhist deities and stories of the Buddha's life were also engraved on stone. Wu Tao-Tzŭ, the famous painter of early T'ang, painted the portrait of Kuan Yin, Goddess of Mercy, which was copied in the form of a stone-engraving and placed in the San-T'ai Cave of Nanking. It remains there

to the present day, and rubbings are still made from it.

It seems, indeed, to have been quite a common practice to reproduce a famous painting as a carving: the wonderful bamboo-paintings of Su Tung-P'o and the plum-tree paintings of P'êng Yü-Ling have been treated in this way, while it is not unusual to find a person's portrait imitated on his tombstone. It is a distinct type of art, on the same principle as that of wood-cuts.

This transference from paper to stone brought a painting within range of the public long before photographic reproductions were invented, through the medium of ink rubbings. The process of ink-rubbing is roughly as follows: a sheet of paper is first spread over the engraving and is then moistened gently with water and left to dry. Then successive thin layers of ink are applied to the surface of the paper, the lines of the carving being clearly visible and left white. The result is a white outline of the engraving on a black background, the reverse of the original painting.

Many big stone-tablets engraved from paintings by well-known artists are to be found in mountain temples or public pavilions, being too large for any other setting. They are sometimes placed in beauty spots, either to

commemorate some historical event or just for
the sake of ornament, and rubbings of them
are on sale to visitors. This may be called the
earliest method of reproducing a painting for
circulation.

I must add that figures and flowers are more
frequently chosen as subjects than any other,
since their outlines are distinct, more so than
those of a landscape.

2. *Frescoes.*–Early records tell us that in
Chou dynasty the main gate of the Palace was
decorated with dragon and tiger paintings, and
also the four gates of 'Hall of Brightness'
were adorned with paintings of the glorious
Emperors Yao and Shun, and the evil Em-
perors Chieh and Ch'ou; this was the origin of
our fresco painting, and was limited at that
time to Palace and municipal buildings. The
Han Emperors continued the tradition of order-
ing frescoes for the moral instruction of their
people; Hsien-Ti of Han had the walls of
certain palace halls bordered with a succession
of prominent generals and political leaders who
had been of service to their master. The
earliest genuine frescoes mentioned in ancient
books were those in the Ling-Kuang Palace of
Lu (Shantung). The purpose of these seems to
be part warning, part adornment; there are
mythical stories and figures of good and
evil spirits, showing the fate that overtakes

evil-doers, but they are interspersed with paintings of birds, animals, and flowers, the usual components of decorative fresco.

From the Chin to the Sui dynasties (*c.* 265-617) fresco enjoyed a popularity unequalled perhaps in any Western art tradition: it rose to the highest position of all in our art practice. It is, of course, a reflection of the demands of society—fresco even better than engraving could contribute to the Buddhist and Taoist temple worship which was flourishing at that time. During the glorious T'ang era, the walls of any temple or monastery would be almost completely covered with this type of painting: as a rule, the master-hand would draw out the sketch, while the colouring would be filled in by his disciples. Frescoes served the same purpose as the shrines and chapels-of-ease in Western churches during the great religious period of the Middle Ages; devout worshippers might pray before the image of Great Buddha or the Goddess of Mercy as the Westerner before a painting of Christ and the Virgin, or in quiet contemplation of the stories of the Divine Life, learn to imitate the Buddha's ways in their own.

In the Tun-Huang Caves, recently discovered, there are frescoes dating from the late fifth to the early eleventh centuries. These caves served as shrines of the Buddhist religion, a tradition

probably emanating from India, and from inscriptions we gather that they were begun in the second half of the fourth century. Evidently the frescoes were a later addition at the time when this type of art was everywhere to be seen in places of religious devotion. These Tun-Huang examples have been photographed and printed by the French archæologist Chavannes, in his great work 'Mission Archéologique dans la Chine Septentrionale.'

Some of the T'ang frescoes were painted on silk and hung round the walls rather than painted directly on to the rock; we know of a portrait of the Yellow Emperor by the versatile Wu Tao-Tzŭ composed in this way. From mid-T'ang until Sung, as the religious impulse weakened and the painting of landscape and flowers was practised by all the leading artists, scenes from Nature, birds and flowers, even the humble insect, were to be found in the place of religious figures on the walls of monastery and temple: partly it showed a secularising of popular thought, partly a sanctifying of Nature; the god was to be found in living things rather than in a specific other-worldly paradise.

Gradually, the artists found that paintings on scrolls of paper or silk, kept privately, were both more convenient and more durable; the number of frescoes rapidly decreased, and nowadays they are very rarely executed. We may

sometimes come across comparatively new ones on temple walls, but they are not the work of any great master, and have little æsthetic value.

3. *Lacquer or Varnish Painting.*—There is no record of its origin, but it must already have been in existence for some time when we first hear of it in connection with decorated chariots; one has the impression of its being a more primitive kind of painting than the familiar brush-and-ink variety. The earliest example of Chinese lacquer known is a drinking-cup, painted by Huo for the Shanglin Park in Han dynasty (*c.* 206 B.C.–A.D. 219). It was found by the Kozloff Expedition, 1924–5, and is now kept in the Scientific Academy, Leningrad. During this dynasty we hear of the wooden shoes and dainty trousseau boxes of a bride decorated with lacquer paintings. There was a renowned lacquer artist in those days named Shêng-T'u P'an, whose technique was greatly admired, but no examples of his work have remained.

From beginning to end of its career, lacquer or varnish painting has always performed the humble office of beautifying other objects. From time to time the medium has grown more delicate, and the brush-work finer: during the late Ch'ing dynasty the varnish painting of Fukien and Kuangtung Provinces

were particularly popular; very beautiful pieces of furniture were decorated with figures and landscapes in this medium. Some examples of the furniture may now be seen in our National Museum.

4. *Banner Painting.*—This is a unique type of art, forming a transition between fresco and scroll painting: we sometimes call the banners 'Moving Frescoes'. Painted as a rule on silk, the banners may be hung up on walls or screens, and they invariably have a religious motive. The most interesting variety is that which is termed 'A Painting for Merit', characteristic of the T'ang period, and connected with ancestor worship. In one of the Buddhist 'scriptures', known as the 'Lotus Sutra', we learn that virtue may be attained through the multiplication of Buddha images—even a schoolboy scratching a figure of Buddha in the dust with an iron nail achieves some grace. Here we see the origin of the vast numbers of Buddha figures in the Rock Shrines, and also of the 'Painting-for-Merit' banners; many of the inscriptions attached to the Shrine images tell how the donors have had them carved for the benefit of their Ancestors' Souls, for the Emperor, for their Family, or for all Sentient Beings. By such an act of grace the donors hoped to free themselves and their relatives from earthly suffering. In the same way, the

T'ang youth would order a portrait of Buddha to be painted upon a silken banner and would himself inscribe it with reverent phrases, to invoke a blessing on his parents and ancestors. Examples of these have been found in the Tun-Huang Caves.

5. *Roll or Scroll Painting.*–When the Westerner hears the words 'Chinese Painting' he generally pictures to himself the characteristic perpendicular sheet of paper or silk mounted on a heavier silk scroll, but in point of fact this form is a comparatively late development in our art. During the T'ang dynasty paintings were made on horizontal rolls, gradually superseding frescoes, but the rolls were of a great and unwieldy length, often more than thirty or forty feet: one had to unroll them bit by bit and 'read' them like a book! However, they were an improvement on the fresco since they could be moved about and more easily preserved. The banner painting led to the development of the perpendicular scroll, the most practical and pleasant form of all. By the time of the Sung dynasty, when silk was manufactured in very exquisite designs, the mounts of these scroll paintings satisfied all that could be desired by a discriminating artist; fresco, banner, and horizontal roll were all superseded. The big change from a wide or long type to one of manageable size, from immovable to

movable, one may almost say from public to private art, marks an even more important stage than would at first appear: it had an influence upon the painter's practice. The chief characteristic of the Chinese landscape-artist's viewpoint is that he tends to imagine himself 'ten thousand miles' away from his object, and his method of perspective is correspondingly influenced. He puts a vast scene into a very small space: towering mountains, leagues of water, miles of land are compressed into the compass of a few feet. Although there are many and profound reasons for this artistic practice, bound up with the Chinese artist's æsthetic beliefs, it is not unreasonable to suppose that the huge dimensions of his original medium—the expansive fresco and the imposing banner—may have had something to do with it.

In Sung times they learned to mount the horizontal roll as well as the perpendicular, but it was shorter now than the old ones of tens of feet, and quite suitable for hanging. We have different types of scroll according to the places where they are to be hung; the 'Scroll for Big Hall' the 'Scroll for Small Hall', the 'Narrow Scroll' for study, reception-room or bedroom. The different subjects tend to be hung in appropriate rooms; the large landscapes usually find place in spacious halls,

while pictures of the 'Gentlemen'—bamboo, pine, plum-blossom, and chrysanthemum, together with stories of famous men of letters, belong to the study or reception-room. A lady's apartment is generally graced with some charming flower paintings.

6. *Portfolio and Album.*–As far as we know, this type of mounting did not originate until Sung times, under the Emperor Hui Tsung; but from those days there are few examples, and evidently that form did not become popular until Ming dynasty. From the intermediate dynasty, the Yüan, two albums only have been discovered: the one being the work of Kao Fan-Shan (Kao Kê-Kung), 'after the style of Mi Fei', and the other containing ten scenes of Ming-Shêng lake by the painter Wu Chung-Kuei. But from the Ming dynasty there are numerous examples, and the reason is clear: in approaching modern times the artists had more and more freedom. Liberated increasingly from Court domination and taught by their own theorists that the free expression of personal vision—of the 'Rhythmic Vitality'—was the only aim of the true artist, they were as a whole very ready to abandon the type of picture that called for long labour, in the course of which inspiration might escape and leave their stream or mountain no more than half-alive! The portfolio picture was necessarily of small

dimensions and could be completed in the first glow of inspiration.

In its origin, however, the portfolio picture may have had a connection with painted fans: these were extremely popular in Southern Sung times, and the greatest masters did not consider it beneath the dignity of their talents to paint small flowers, birds, or graceful scenes for silk fans. But a fan is easily damaged, and we know that these paintings by eminent artists were often detached from the frame and mounted in portfolios, in groups of ten or twelve; subsequently several of these were bound together under a fresh cover in the form of an album. There were also very small paintings in Sung days, too small for the ordinary kind of mounting, and these too were collected and bound in albums; this is a type which the Ming artists perpetuated.

Originally, it was usual to collect together examples of ten or twelve different artists, but since the prominent Ming painter, Shên Shih-T'ien (Shên Chou) made his albums from various examples of his own work, it has become quite a common event for an artist to paint a group of several different styles or different subjects and to mount them together in book form. The albums reached the height of popularity in the last dynasty, the Ch'ing.

7. *Fan Painting.*—Fan-making is an art of

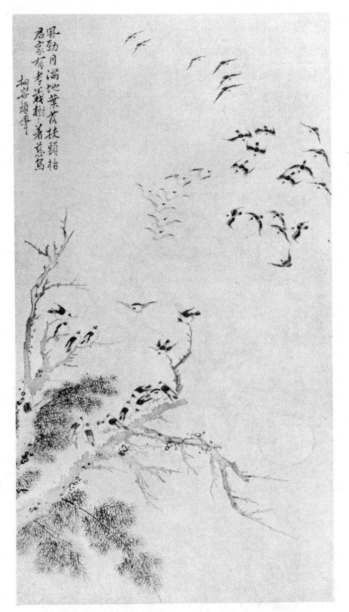

XXIII BIRDS RETURNING THROUGH A
SNOWY SKY Yen T'ung-K'o (Ch'ing)

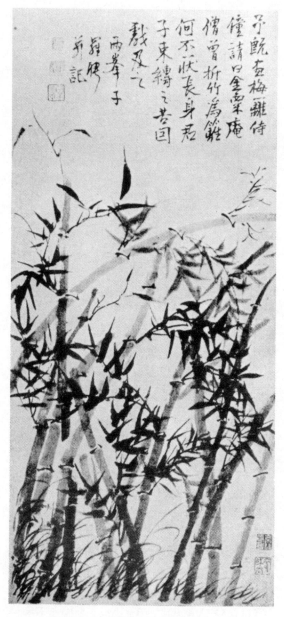

XXIV BAMBOOS Lo P'in (Ch'ing)

long standing; the East is renowned for its extremes of heat and cold, and I have noticed that no Oriental Potentate or maiden is ever presented on the Western stage, in play or pantomime, without the inevitable fan! The earliest materials used were apparently palm-leaf and feather; later fans were made of silk or folded paper, painted or inscribed. Although artistic practice was still circumscribed rather strictly in the Han dynasty, there were already some examples of fan-painting, a little lacking in elegance no doubt. Wang Hsi-Chih, the renowned calligraphist of the Eastern Chin dynasty (*c.* A.D. 317–419) whose writing is described as being 'as light as floating clouds and as vigorous as a startled dragon', used to inscribe poetry on his fans rather than paintings. The T'ang artists still preferred large-scale paintings, so that the art of fan-making did not become widespread until Sung, and then it became a popular craze. The Emperor Hui Tsung set the fashion with his own brush: he was a great art patron and a dilettante in each form of artistic creation. Forthwith, officials and people hastened to imitate him, by way of compliment and adulation: all the Court painters, the Academicians, made fans and offered them to the Emperor for his approval. You will find that almost every collection of Chinese art will include

some examples of Sung fans. Most of them are made from fine silk on frames of varied ingenious forms—square, round, octagonal, and so on. It was, as you know, a great period of 'Flower and Bird' paintings, and these light and delicate subjects were particularly well adapted to fans, both for their size and office. Yüan dynasty artists followed the same custom, but Ming and Ch'ing instituted the type with which you are most familiar in the West, the folded-paper variety. In later days fan-paintings were commercialised, and fans may now be printed by machinery and bought for a few pence; nevertheless, the artistic side has not been neglected and the man of letters to the present day will be ashamed to use the vulgar kind, but will still patronise the true artist. His will be painted by someone of good artistic repute, inscribed and signed by him, and the owner's name added. It is as well worth while to make a collection of elegant fans as of roll or scroll paintings.

8. *Screen Painting*.—Screens were used as early as the Chou dynasty, several centuries B.C., but there does not appear to have been any painting on them until Han times. We hear that the Emperor Kuang-Wu of the Later Han ordered a succession of screens to be adorned with portraits of famous ladies, and that the painter Shih Chi-Lung put birds, animals, and

all kinds of human figures upon his. In T'ang days screen-painting rose to high favour, and landscape was added to the range of subjects: you will find many poems of the great poets of T'ang written in praise of some screen-painting.

A screen is for utility—it has the special purpose of sheltering some object or person. In the old days our unmarried girls used to sit behind them to listen to the men's conversation without being seen, or to play their music there—the opening for many a romance! It became a necessary part of the furniture of a hall or room and it had to be adorned with ornaments or paintings. It is usually formed of four, six, eight, or twelve folding wooden leaves, and may be opened out like a long sheet. Some artists would paint a single scene across the whole width; others would paint separate pictures on each of the leaves, forming a series of similar subjects or a story told like a modern cartoon. Or each leaf may contain a painting by a different artist, or there may be alternate strips of painting and calligraphy.

9. *Kê-Ssŭ and Embroidered Paintings*.—The Kozloff Expedition in 1924–5 in the region of Lake Baikal, brought back a number of fragments of figured silk dated from the Han dynasty (*c*. 206 B.C.–A.D. 220). This indicates that Chinese silk-weaving embodying a design has a very long history. At first the design was

very simple and more a pattern than a picture. During the Sui and T'ang dynasties a variety of elaborate and delicate designs were woven in silk, which soon led to the development of Kê-Ssŭ painting. In the Sung period weavers used to imitate an actual painting by some well-known artist, achieving, within its limitations, a result as vivid and delicate in colour and tone as the original. It was in this period that this branch of our pictorial art reached a peak of perfection—the loveliest pieces of all time were produced. Kê-Ssŭ is really tapestry in the Western sense of the word, though we have never produced such masterpieces as those of Bayeux. Our weavers use a very fine silk, so that there is no embossed effect. Embroidered painting differs from Kê-Ssŭ only in technique; the design is stitched with coloured silks on to a sketch on a piece of silk, instead of being woven. The earliest example yet found is the embroidered banner representing Sakyamuni with attendants (eighth–ninth century) in the British Museum, which came from the Caves of the Ten-thousand Buddhas at Tunhuang. At the present day, Soochow, Hanchow, Hunan, and Kuangtung are still known for their beautiful embroideries, those of Hunan being considered the finest and most colourful of all.

10. *Porcelain painting.*–This art was one of the latest to develop: in T'ang and Sung we

may find some pottery with designs upon it very much resembling painting, but the true painting method was not used, as far as we can judge, until the Ch'ing dynasty (1644-1912), especially under the Emperors K'ang Hsi and Ch'ien Lung. K'ang Hsi porcelain is chiefly famous for its exquisite clear colouring—blue and ox-blood especially; Ch'ien Lung for painting designs. The porcelain of this last Emperor reached the highest degree of delicacy in colour and form: it is said that he used to command the porcelain-maker to mould a plain piece first, and then handed it over to one of the Court painters for colouring; afterwards it was put in ovens to set and fix. These are true works of art and we are just as anxious to have them in our houses as a painting scroll.

11. *Natural Stone Painting.*—I doubt whether this type of painting could be found anywhere in the West, with its more sophisticated ideals of art. We have two famous poets, Yüan Wei-Chih of T'ang and Su Tung-P'o of Sung, who even wrote poems in admiration of it, calling it 'the Painting of Heaven'.

From the Early T'ang period we have discovered the beauties of certain types of stone or marbles: they have a kind of black marking in them formed from some natural constituent or metal compound. We cut the stones and smooth the surface, picking out those examples

which seem of themselves to present a ready-painted scene. Though the stone-cutter need not be an artist, the searcher must be a person of sure æsthetic taste. He does not actually create this work, but his inner mind and penetrating eyes have been active in the process of discovering this creation, which is an art in itself. He will look among the natural markings for shapes that seem to be like a landscape, a bird, a flower; sometimes he cuts through a stone at a certain angle to find an outline as vivid and lifelike as anything we could paint with brush and ink! In the early days of the art, most of the best stones were found in Chu-Jung of Kiangsu and Fêng-Hua of Chekiang. During the Ming dynasty some very beautiful marbles were found at Tien-Tsan mountain in Ta-Li Fu of Yün-Nan, and nearly all this type of painting was made in that district at that time. You may think that 'painting' is a somewhat pretentious name for the simple process of stone-cutting, but it does, in fact, call for a high degree of artistic talent. When a scholar Yüan Yüan was governor of Yün-Nan he made hundreds of the paintings, and wrote a book about them, discussing methods of choosing the stones, determining the cut and so on: he gave a name to every type and really elevated the process to the position of an art. The people of that district

still make the paintings but they lack the taste
or talent of Yüan Yüan for their achievement
does not approach his: the stones are the same
but the artistic touch has been lost: they will
no longer reveal their secret!

12. *Fire-painting.*—There was once an artist
of the Ch'in dynasty called T'ang P'êng or
T'ang T'ien-Chih, who could mould insects,
grasses, flowers, bamboos, even landscapes out
of melted iron, as living as any painting by a
clever artist, but like Yüan Yüan with his
stones, T'ang P'êng seems to have taken his
secret with him to the grave; since his death
no one has entirely succeeded in painting with
the medium of fire.

INDEX I

INDEX II